Turner

Eric Shanes

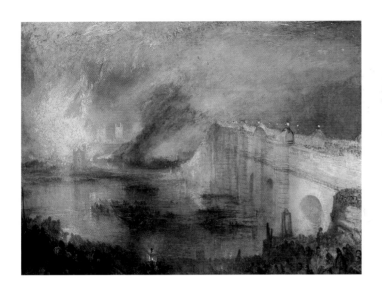

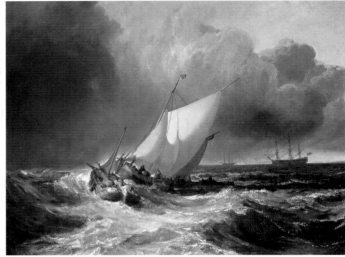

© Confidential Concepts, worldwide, USA, 2004
© Sirrocco, London, 2004 (English version)

Published in 2004 by Grange Books
an imprint of Grange Books Plc
The Grange Kingsnorth Industrial Estate
Hoo, nr Rochester Kent ME3 9ND
www.Grangebooks.co.uk
ISBN 1-84013-654-5
Printed in China

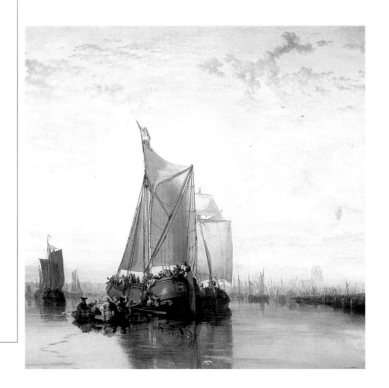

Turner

Eric Shanes

Grange
BOOKS

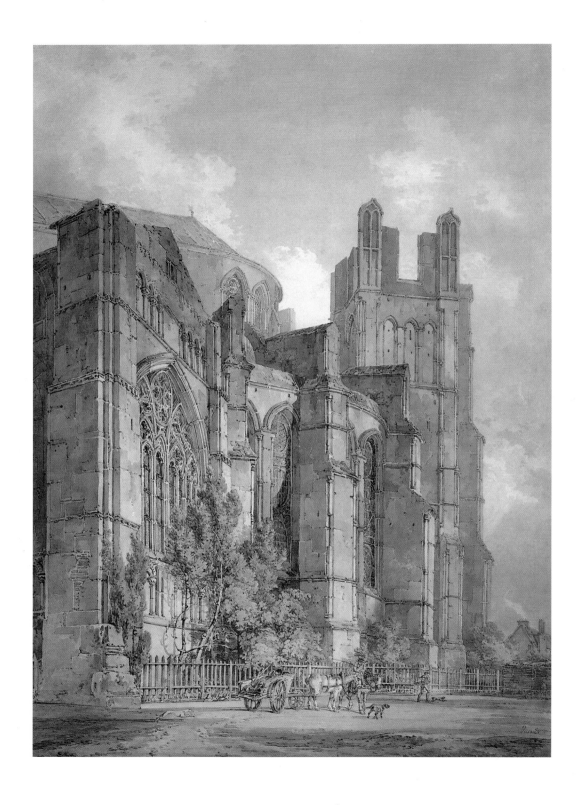

J.M.W. Turner: a Landscape and Marine Painter without Equal?

From darkness to light: perhaps no painter in the history of western art evolved over a greater visual span than Turner. If we compare one of his earliest exhibited masterworks, such as the fairly low-keyed *St. Anselm's Chapel, with part of Thomas-à-Becket's crown, Canterbury Cathedral* of 1794, with a brilliantly-keyed picture dating from the 1840s, such as *The Falls of the Clyde*, it seems hard to credit that the two images stemmed from the same hand, so vastly do they differ in appearance.

Yet this apparent disjunction can easily obscure the profound continuity that underpins Turner's art, just as the dazzling colour, high tonality and loose forms of the late images can lead to the belief that the painter shared the aims of the French Impressionists or even that he wanted to be some kind of abstractionist, both of which are completely untrue notions.

Instead, this continuity demonstrates how single-mindedly Turner pursued his early idealising goals and how magnificently he finally attained them.

Joseph Mallord William Turner was born in London on 23 April 1775, the son of a barber. In 1789 he began studying at the only art school in Britain, the Royal Academy Schools.

He supplemented the plaster modelling and life drawing he was exclusively taught there by apprenticing with journeyman, topographer and architectural watercolourist, Thomas Malton Jr. (1748-1804).

1. *St. Anselm's Chapel, with part of Thomas-à-Becket's crown, Canterbury Cathedral*, R.A. 1794. Watercolour, 51.7 x 37.4 cm. Whitworth Art Gallery, Manchester, U.K.

From 1791 to 1792, he also worked briefly as a scenic painter at the Pantheon Opera House. In 1791 he embarked upon the first of his annual tours to gain topographical material for his images; over the rest of his career he would undertake some fifty-six additional journeys throughout Britain and the Continent.

In 1793, the Royal Society of Arts awarded the seventeen-year-old its "Greater Silver Pallet" award for landscape drawing. To survive financially, Turner needed to sell from the outset.

Accordingly, a few months after entering the R.A. Schools he launched himself with a finished watercolour, *The Archbishop's Palace, Lambeth* (p. 8), in the 1790 Royal Academy Exhibition.

Up to 1795 he displayed only finished watercolours in the annual shows, but in 1796 he displayed his first oil painting at the Royal Academy.

This was the *Fishermen at Sea* of 1796 (p. 12), and it demonstrates how fully the painter already understood wave-formation, reflectivity and the underlying motion of the sea.

2. *Self-Portrait,*
ca. 1798.
Oil on canvas,
74.5 x 58.5 cm.
Turner Bequest,
Tate Britain, London.

From this time onwards, his depictions of the sea would become ever more masterly, soon achieving a mimetic and expressive power that is unrivalled in the history of marine painting.

After 1796 Turner annually displayed oils at the Royal Academy, and only in 1805, 1821, 1824, 1848 and 1851 would he fail to do so.

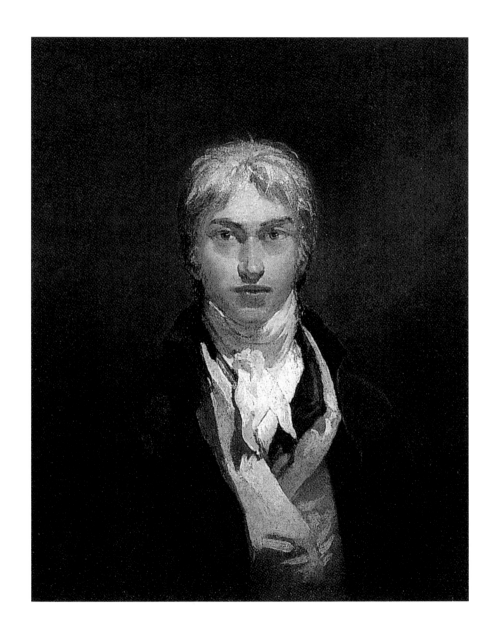

3. ***The Archbishop's
 Palace, Lambeth***,
 R.A. 1790.
 A4, watercolour,
 26.3 x 37.8 cm.
 Indianapolis Museum
 of Art, Indianapolis,
 Indiana, U.S.A.

4. ***The Pantheon,
 the Morning after
 the Fire***, R.A. 1792.
 Watercolour,
 39.5 x 51.5 cm.
 Turner Bequest,
 Tate Britain, London.

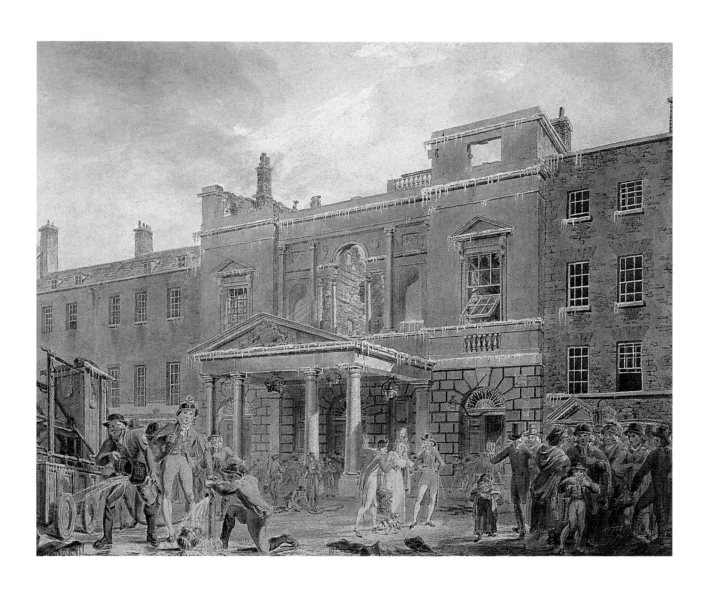

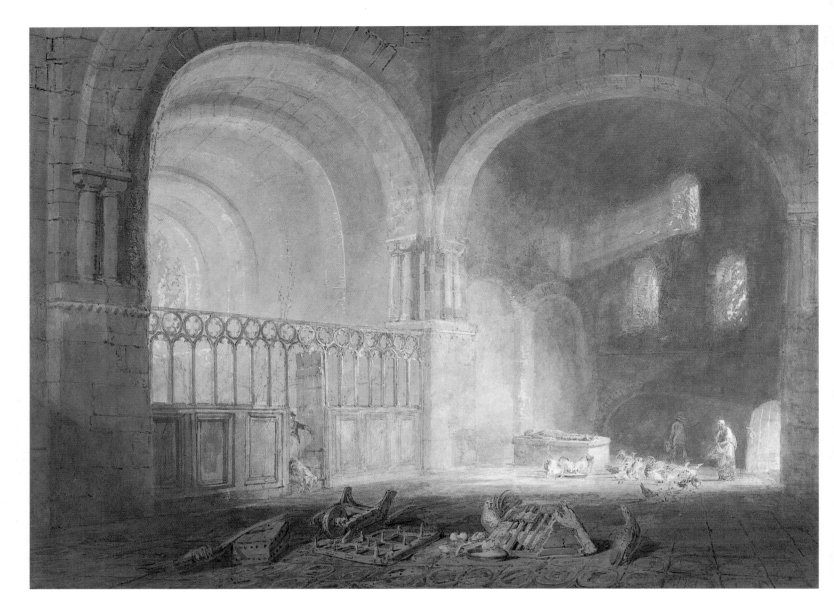

5. ***Transept of Ewenny***
Priory, Glamorganshire,
R.A. 1797.
Watercolour,
40 x 55.9 cm.
National Museum of
Wales, Cardiff.

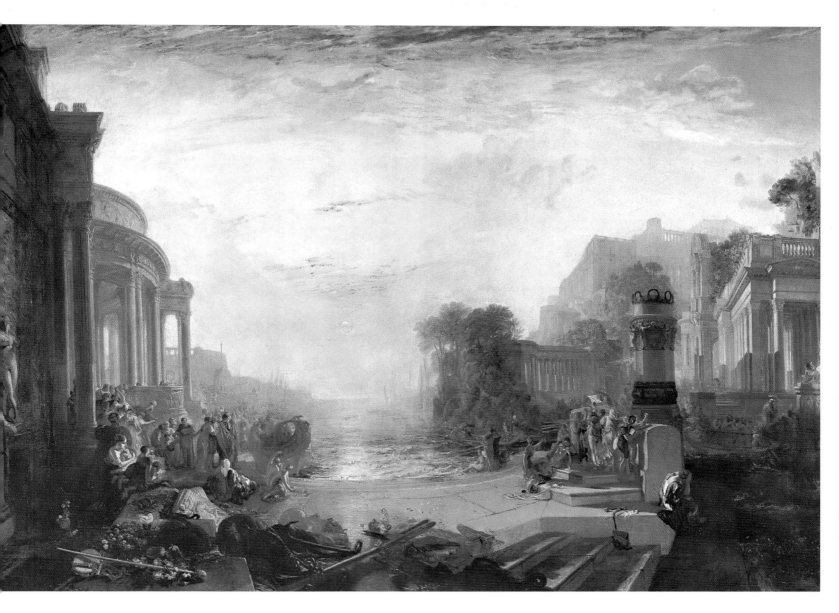

6. **The Decline of the Carthaginian Empire**, R.A. 1817.
Oil on canvas,
170 x 238.5 cm.
Turner Bequest,
Tate Britain, London.

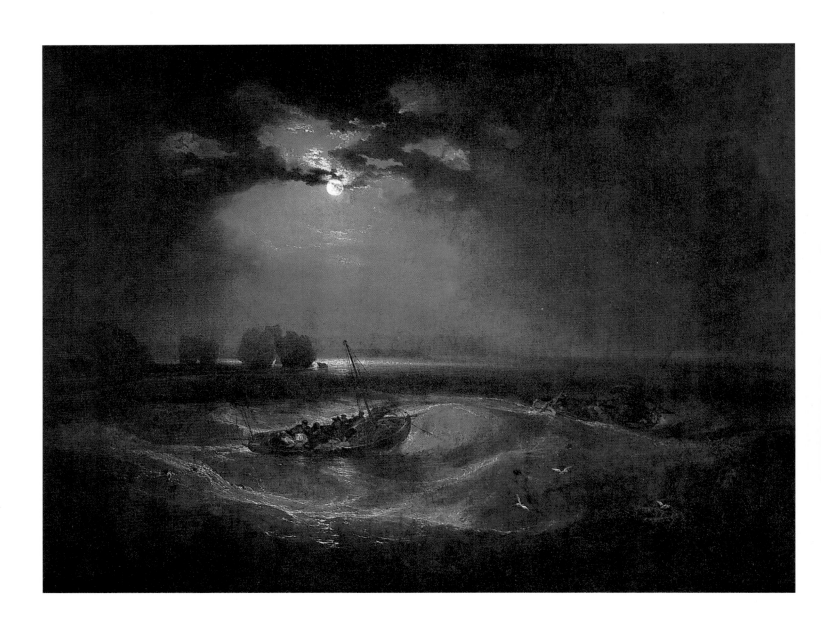

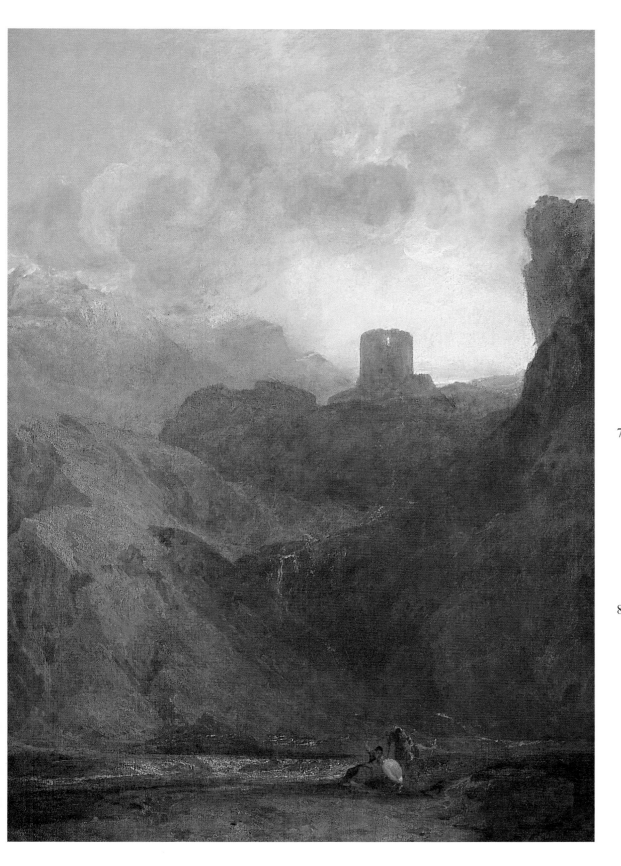

7. *Fishermen at Sea*,
 R.A. 1796.
 Oil on canvas,
 91.5 x 122.4 cm.
 Turner Bequest,
 Tate Britain, London.

8. *Dolbadern Castle,*
 North Wales,
 R.A. 1800.
 Oil on canvas,
 119.5 x 90.2 cm.
 Royal Academy of
 Arts, London.

Towards the end of 1799, Turner's outstanding talents received official recognition with his election as an Associate Royal Academician.

In 1801, he created a sensation at the Academy with a marine subject in oil, the so-called "Bridgewater Seapiece" whose full title is *Dutch Boats in a Gale: Fishermen endeavouring to put their Fish on Board.*

Largely as a result of that impact, he was elected a full Royal Academician in 1802, at the age of just twenty-six. He was the youngest Academician to have been elected to date.

Turner's new status guaranteed him an audience, for Academicians enjoyed the automatic right to display up to eight works in the annual Exhibition.

9. *Dutch Boats in a Gale: Fishermen endeavouring to put their Fish on Board* also called *"The Bridgewater Seapiece,"* R.A. 1801. Oil on canvas, 162.5 x 222 cm. Private Collection, on loan to the National Gallery, London.

Later in 1802, Turner took advantage of the brief peace between Britain and France to visit Switzerland. For years afterwards he drew from the sketchbook material gathered there.

In 1806, Turner embarked upon a major mezzotint engraving project, the *Liber Studiorum*. Eventually he made one hundred sepia watercolours for this project, of which seventy-one were reproduced by means of engraving. The following year Turner was elected the Royal Academy Professor of Perspective.

Over the next three years he embarked upon a rigorous reading, or re-reading, of the theoretical literature of art.

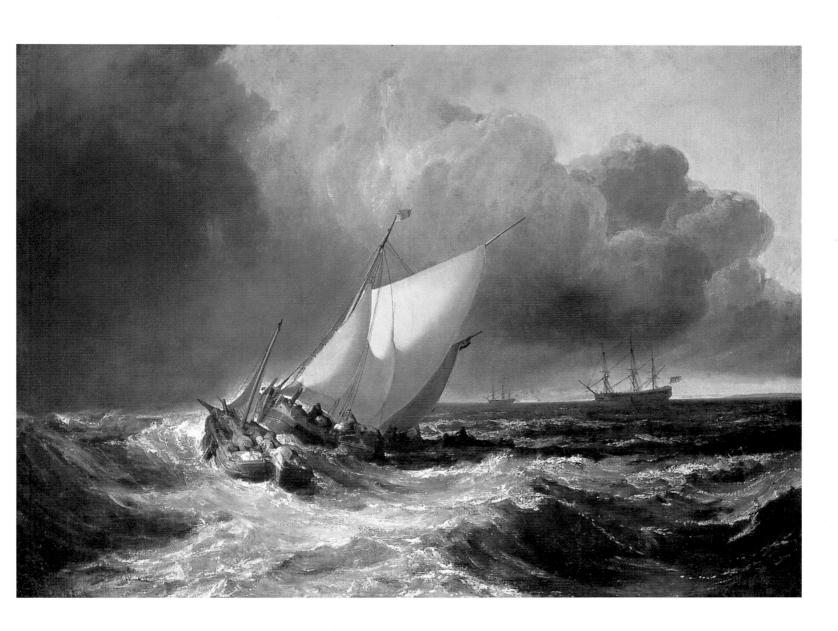

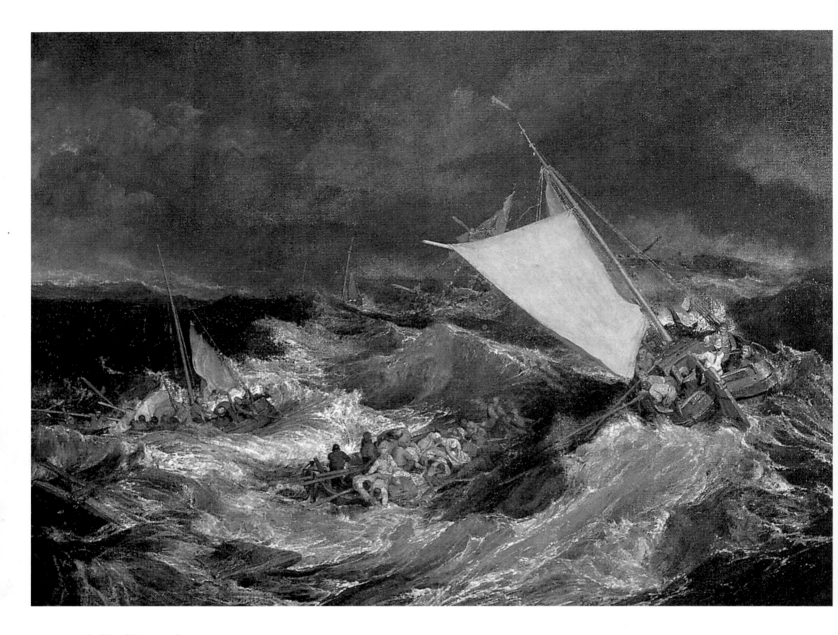

10. *The Shipwreck,*

Turner's Gallery, 1805.

Oil on canvas,

170.5 x 241.5 cm.

Turner Bequest,

Tate Britain, London.

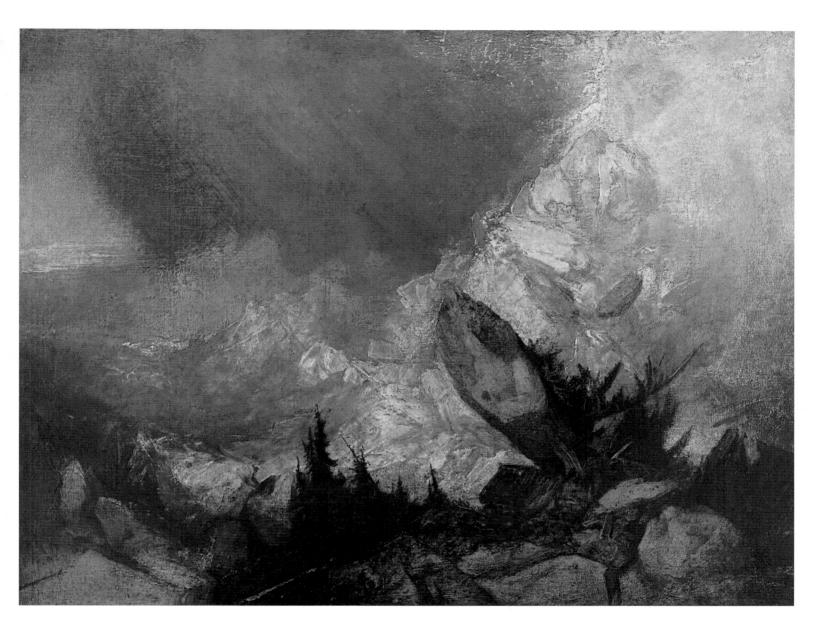

11. ***The Fall of an Avalanche***

in the Grisons, 1810.

Oil on canvas,

90 x 120 cm.

Turner Bequest,

Tate Britain, London.

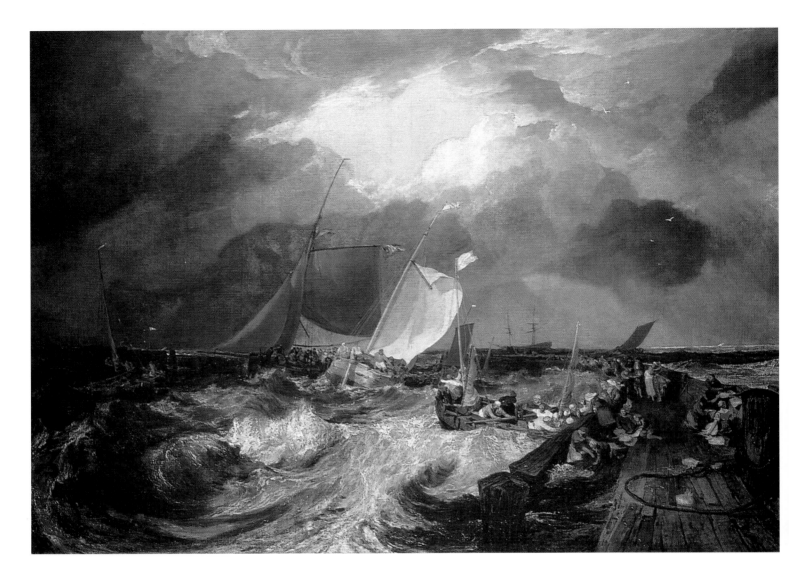

12. *Calais Pier, with French Poissards preparing for Sea: an English packet arriving*, R.A. 1803.
Oil on canvas,
172 x 240 cm.
Turner Bequest,
National Gallery, London.

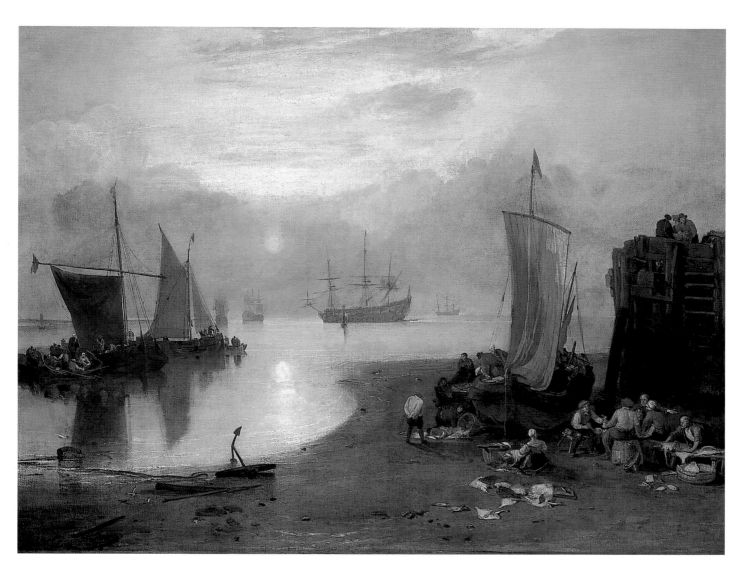

13. ***Sun Rising through Vapour; Fisherman Cleaning and Selling Fish***, R.A. 1807.
Oil on canvas,
134.5 x 179 cm.
Turner Bequest,
National Gallery, London.

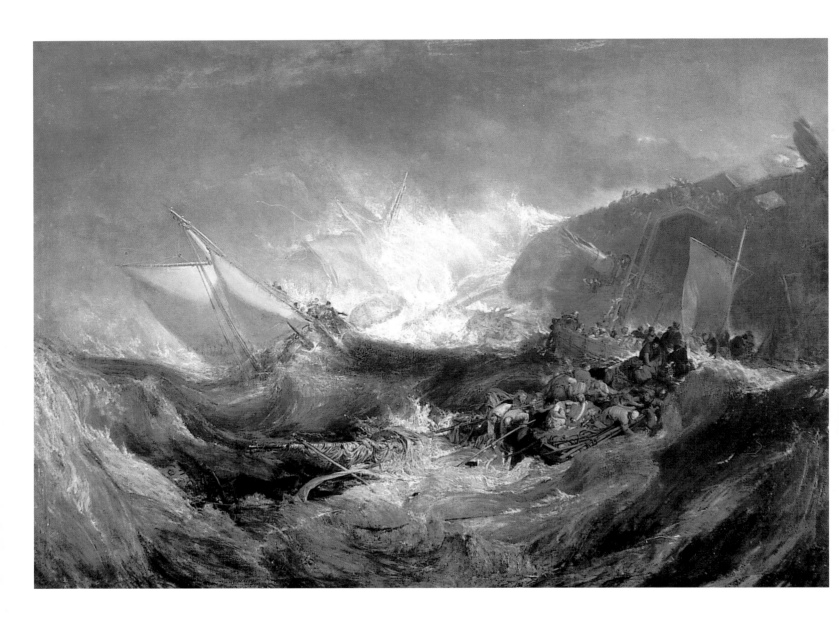

He began to deliver annual courses of six lectures in 1811 and continued those sets of talks almost annually until 1828 (he resigned the professorship ten years later).

One of the lectures contains a statement that represents the essence of his artistic thinking:

"...it is necessary to mark the greater from the lesser truth: namely the larger and more liberal idea of nature from the comparatively narrow and confined; namely that which addresses itself to the imagination from that which is solely addressed to the eye."

By early 1805, Turner began residing for parts of the year outside London. While living there he had a boat built for use as a floating studio upon the river Thames and painted a number of oil sketches in open air.

Although the sketches are very vivacious and prefigure French Impressionism, Turner set no store on them and never exhibited them.

In 1811, he began building a small villa in Twickenham, to the west of London. He designed the house himself; it still exists, although somewhat altered over the years.

Between 1802 and 1811 Turner did little touring, being extremely busy producing oils as well as innumerable watercolours on commission. His clientele continued to expand and came to include many of the leading collectors of the day.

14. *The Wreck of a Transport Ship*, ca. 1810. Oil on canvas, 172.7 x 241.2 cm. Fundaçao Calouste Gulbenkian, Lisbon.

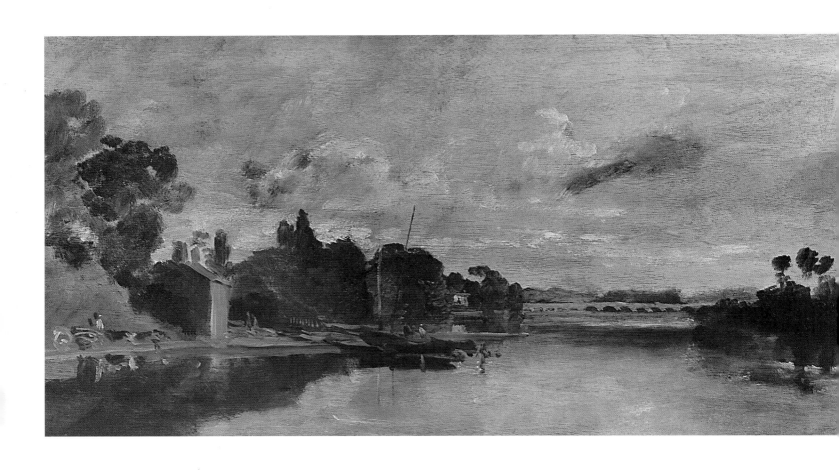

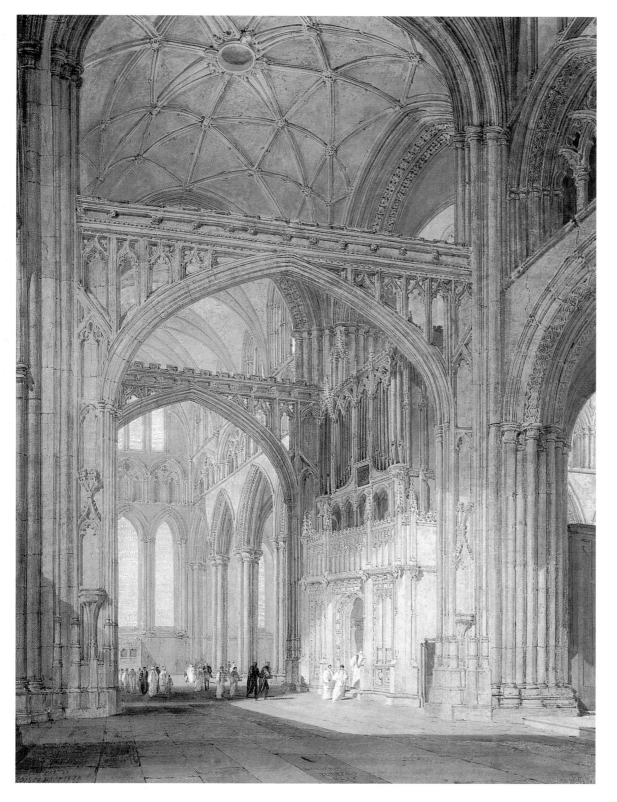

15. ***The Thames near Walton Bridges***,
ca. 1805.
Oil on mahogany
veneer laid on panel,
37 x 73.5 cm.
Turner Bequest,
Tate Britain, London.

16. ***Interior of Salisbury Cathedral, Looking towards the North Transept***,
ca. 1802-1805.
Watercolour,
66 x 50.8 cm.
Salisbury and South
Wiltshire Museum.

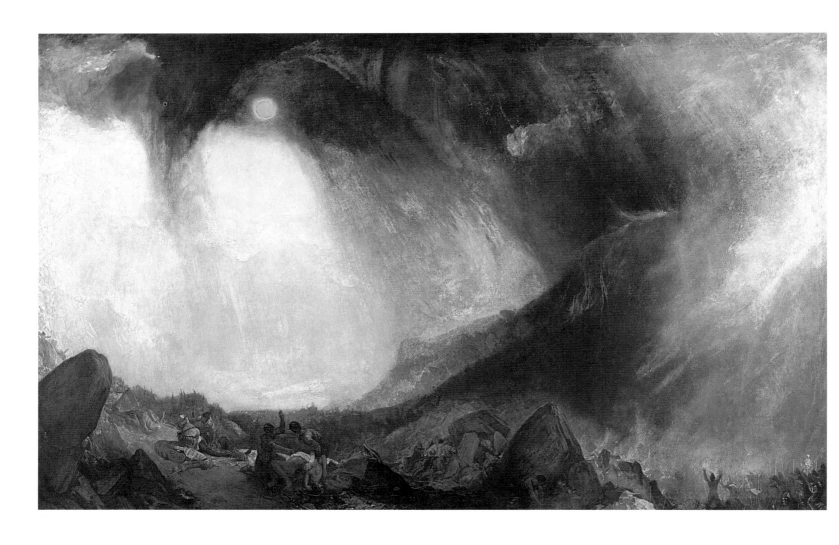

17. ***Snow Storm: Hannibal
and his Army crossing the
Alps***, R.A. 1812.
Oil on canvas,
146 x 237.5 cm.
Turner Bequest,
Tate Britain, London.

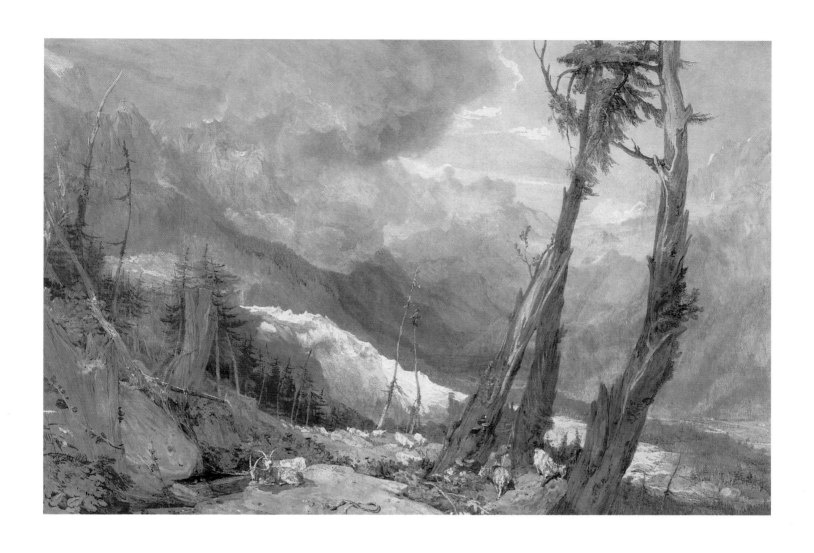

18. ***Mer de Glace, in the***
Valley of Chamouni,
Switzerland, ca. 1814.
Watercolour,
68.5 x 101.5 cm.
Yale Center for British
Art, New Haven, Conn.

In 1812, Turner exhibited an unusually important picture at the Royal Academy, *Snow Storm: Hannibal and his Army crossing the Alps* (p. 24).

The immediate inspiration for the work came to Turner late in the summer of 1810 when he was staying at a country house in Yorkshire, in the north of England.

One day he was witnessed by the son of his host standing at the doorway of the house and looking out over Wharfedale; as the younger man later recalled, Turner shouted:

"'Come here! Come here! Look at this thunder-storm. Isn't it grand? -- Isn't it wonderful? -- Isn't it sublime?'

All this time he was making notes of its form and colour on the back of a letter. I proposed some better drawing-block, but he said it did very well. He was absorbed -- he was entranced.

19. *Dido building Carthage; or, the Rise of the Carthaginian Empire*, R.A. 1815. Oil on canvas, 155.5 x 232 cm. National Gallery, London.

There was the storm rolling and sweeping and shafting out its lightning over the Yorkshire hills. Presently the storm passed, and he finished. 'There!' said he. 'In two years you will see this again, and call it *Hannibal Crossing the Alps*.'"

This story vividly indicates both the force of Turner's inner eye and also his precise aesthetic leanings, for his immediate placing of a sublime natural effect at the service of an epic historical subject is profoundly imaginative and poetical -- clearly the vastness of nature was merely a starting point for Turner.

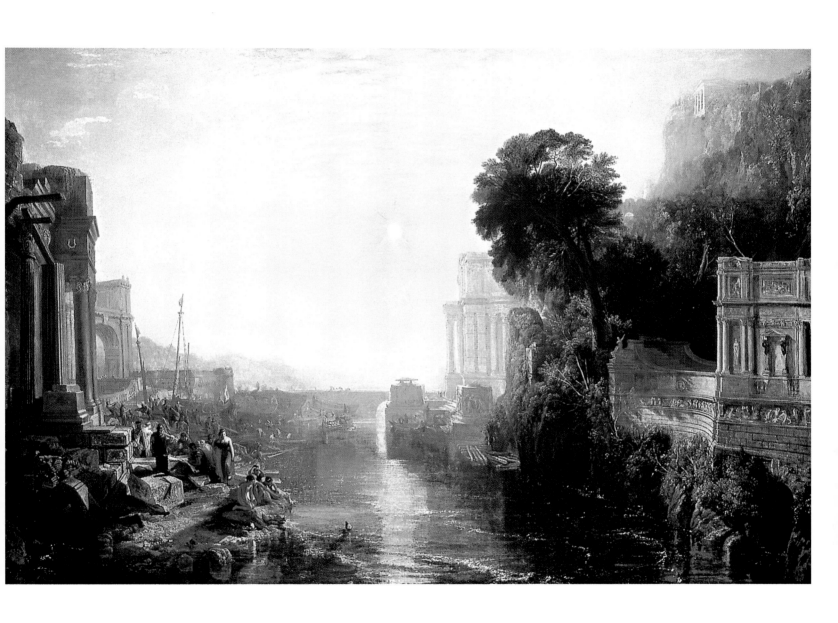

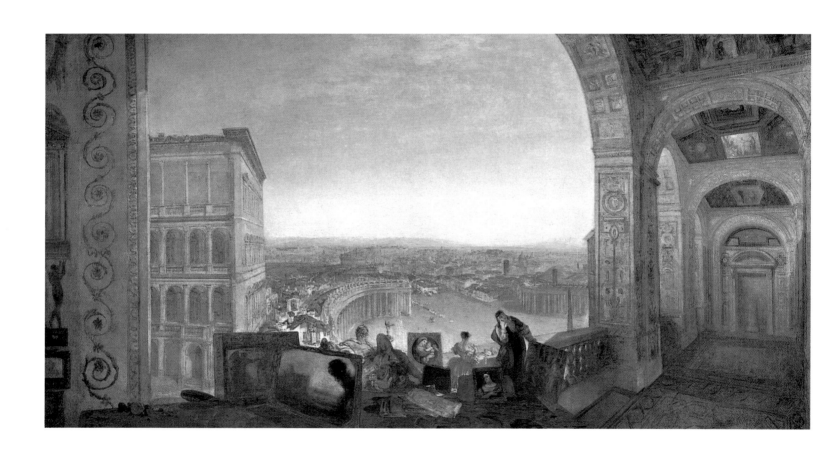

In 1811, Turner was invited to make a series of watercolours for engraved reproduction in a series depicting the major towns and sights along the southern coast of England.

The result was the artist's first truly creative set of finished watercolours elaborated for engraving, the "Picturesque Views on the Southern Coast of England" series.

In order to gain topographical material for the watercolours, Turner toured the West Country in 1811 and 1813 (and possibly in 1814 as well).

In 1815, Turner displayed what he considered to be his greatest painting to date, *Dido building Carthage; or the Rise of the Carthaginian Empire* (p. 27).

Turner called the canvas his "chef d'oeuvre." It is not surprising he particularly esteemed it for he had long wanted to paint a seaport scene worthy of comparison with the French artist Claude le Lorrain, and with the painting he succeeded.

Two years later he exhibited the companion to *Dido building Carthage*, namely *The Decline of the Carthaginian Empire* (p. 11). Such linked statements of the rise and fall of Empires would become very common in Turner's art and demonstrate his pronounced moral sense.

In 1817, Turner again crossed to the Continent, this time to explore the Lowlands and the Rhineland. In 1819, he travelled to Italy where he stayed for six months before returning laden with over two thousand sketches, studies and rough watercolours.

20. *Rome, from the Vatican. Raffalle, Accompanied by La Fornarina, Preparing his Pictures for the Decoration of the Loggia*, R.A. 1820. Oil on canvas, 177 x 335.5 cm. Turner Bequest, Tate Britain, London.

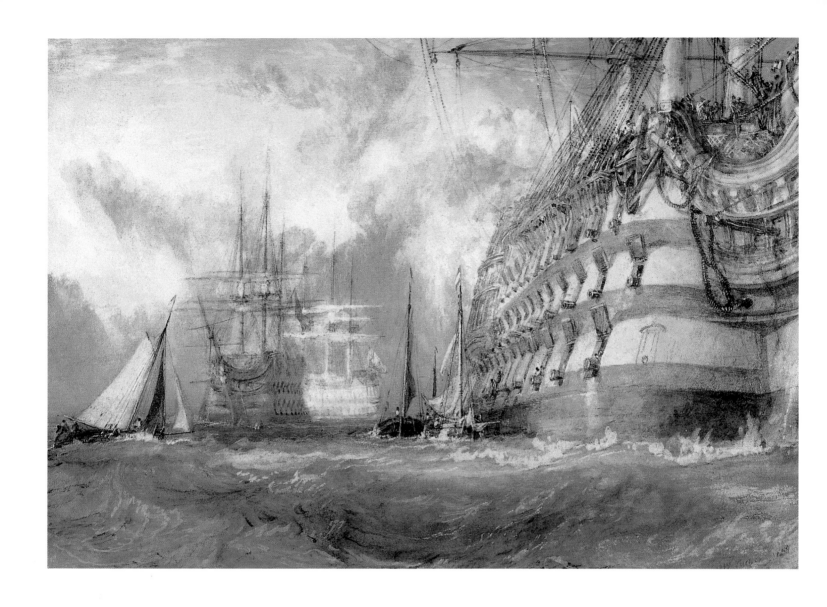

21. ***First-Rate, Taking in***
Stores, 1818.
Watercolour,
28.6 x 39.7 cm.
Cecil Higgins Art
Gallery, Bedford, U.K.

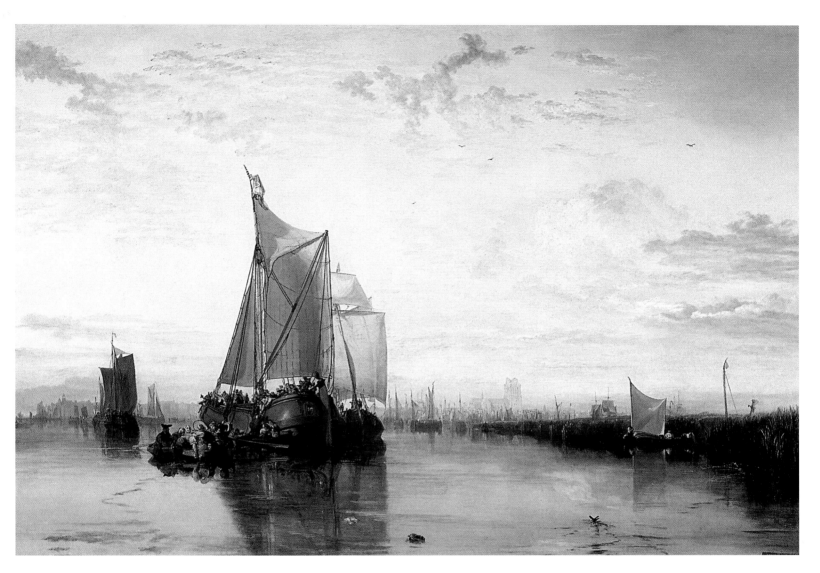

22. ***Dort, or Dordrecht, the***
Dort Packet-Boat from
Rotterdam becalmed,
R.A. 1818.
Oil on canvas,
157.5 x 233 cm.
Yale Center for British Art,
New Haven, Conn.

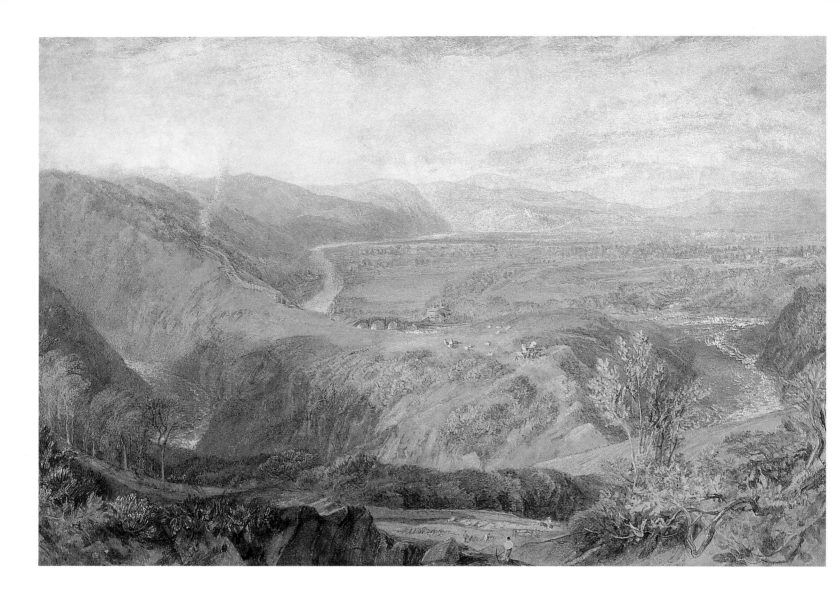

23. ***Crook of Lune, Looking***

towards Hornby Castle,

ca. 1817.

Watercolour,

28 x 41.7 cm.

Courtauld Institute of Art,

University of London.

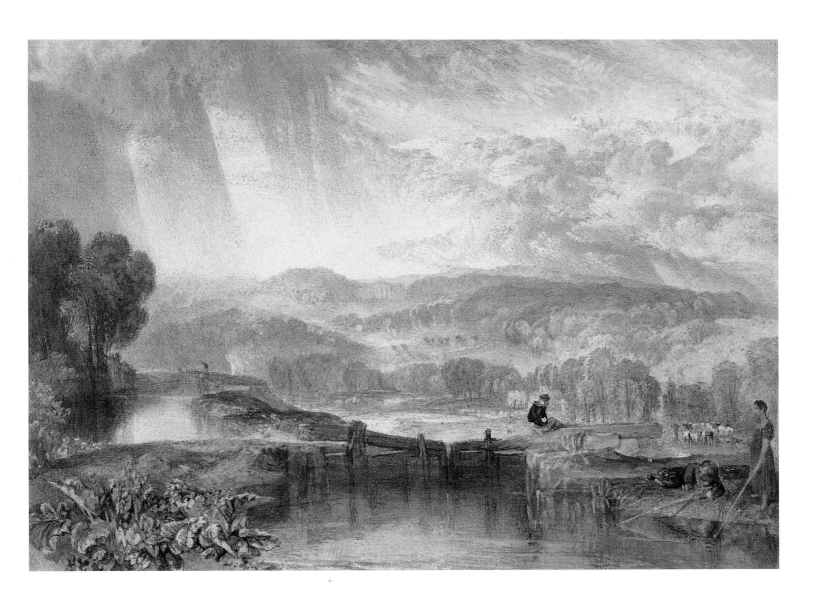

24. ***More Park, near***
Watford, on the River
Colne, 1822.
Watercolour,
15.7 x 22.1 cm.
Turner Bequest,
Tate Britain, London.

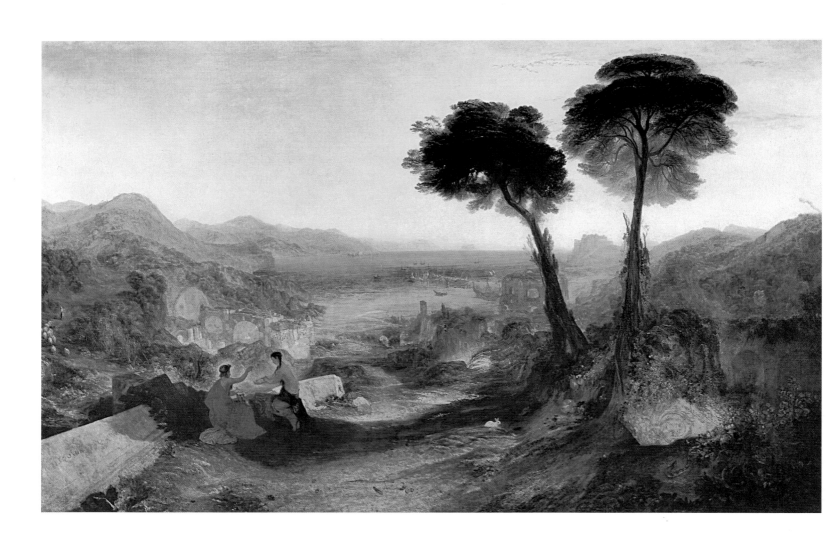

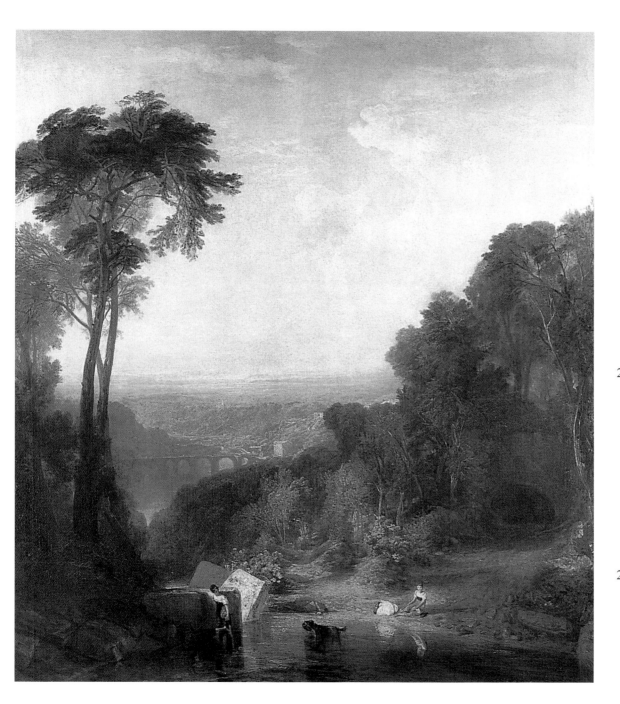

25. ***The Bay of Baiae:***

Apollo and the Sibyl,

R.A. 1823.

Oil on canvas,

145.5 x 239 cm.

Turner Bequest,

Tate Britain, London.

26. ***Crossing the Brook***,

1815.

Oil on canvas,

193 x 165 cm.

Turner Bequest,

Tate Britain, London.

During the 1810s and 1820s Turner produced finished watercolours for further line-engraving schemes, including an unsuccessful "History of Richmondshire" project, a series of views of the rivers of England, a group of depictions of English ports and harbours, and a "Marine Views" group.

The seven large drawings comprising the latter set are unquestionably the finest seascapes in watercolour ever created.

By 1824, Turner had begun work on what would prove to be his longest-lasting and most ambitious engraving project, the "Picturesque Views in England and Wales" series, for which one hundred watercolours were eventually created.

Early in his career, Turner had, of necessity, evolved a production-line method for making his watercolours. Such a procedure proved of enormous benefit when creating large numbers of watercolours for engraving.

Two accounts of the artist's watercolour technique have come down to us from the same witness:

27. *Mount Vesuvius in*
 Eruption, 1817.
 Watercolour,
 28.6 x 39.7 cm.
 Yale Center for British
 Art, New Haven, Conn.

"There were four drawing boards, each of which had a handle screwed to the back.

Turner, after sketching the subject in a fluent manner, grasped the handle and plunged the whole drawing into a pail of water by his side.

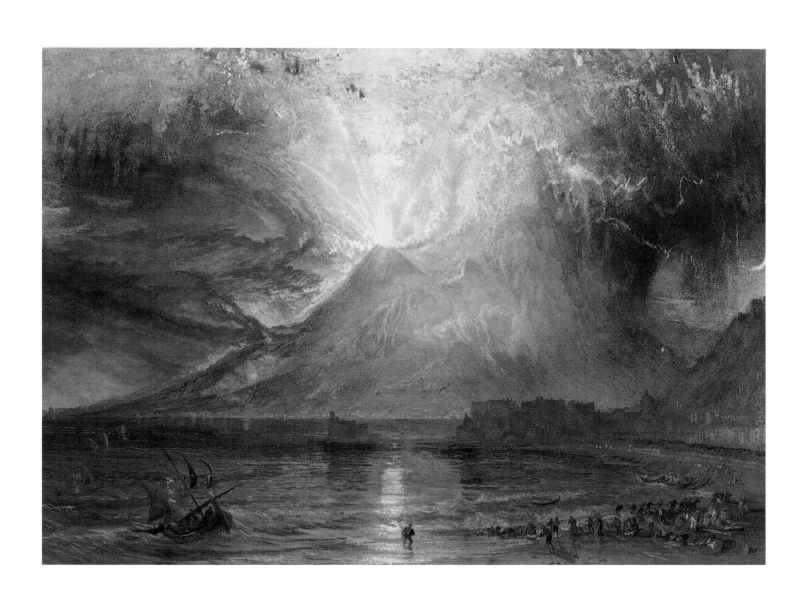

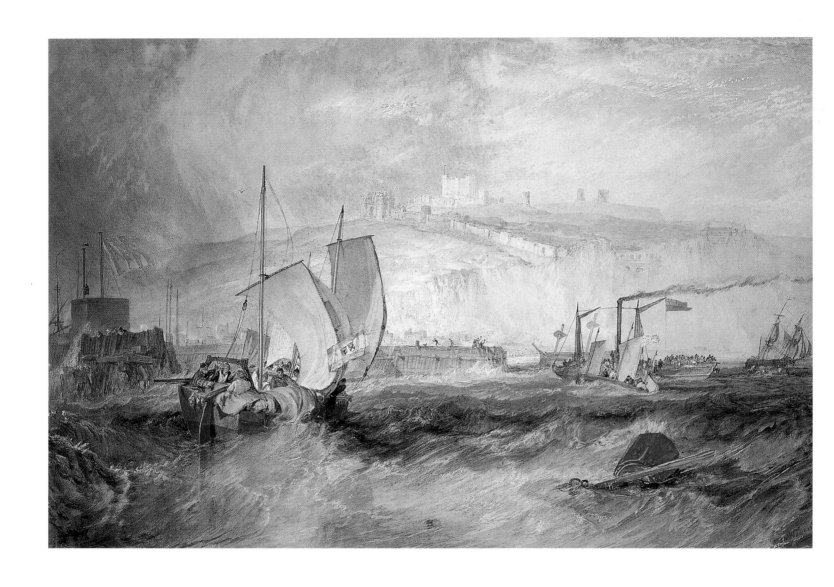

28. *Dover Castle*, 1822.

Watercolour,

43.2 x 62.9 cm.

Museum of Fine Arts,

Boston, Mass.

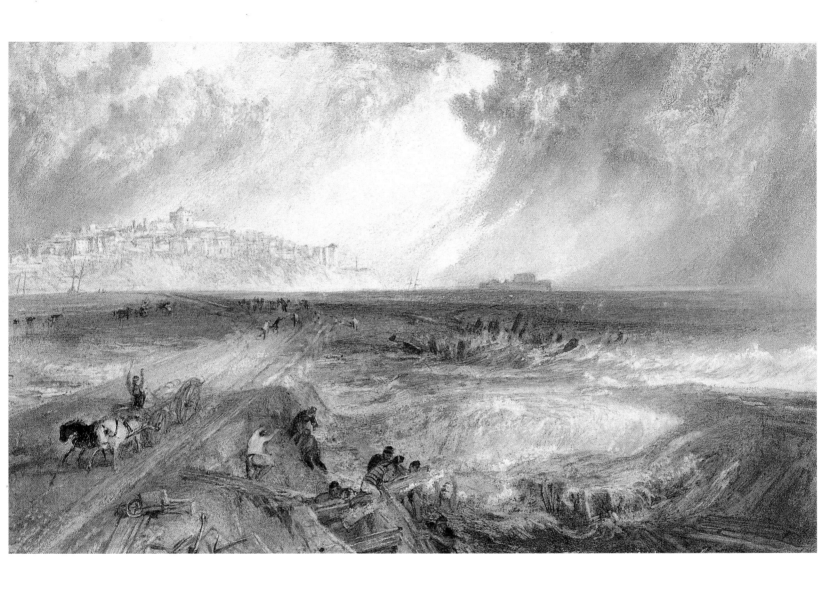

29. ***Rye, Sussex***, ca. 1823.
Watercolour,
14.5 x 22.7 cm.
National Museum of
Wales, Cardiff.

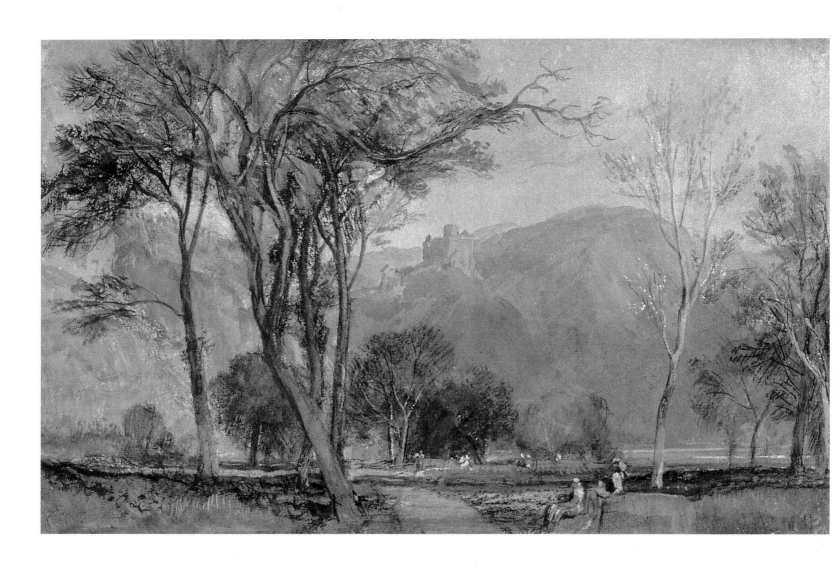

30. ***Marxbourg and Brugberg on the Rhine***, 1820. Watercolour, 29.1 x 45.8 cm. British Museum, London.

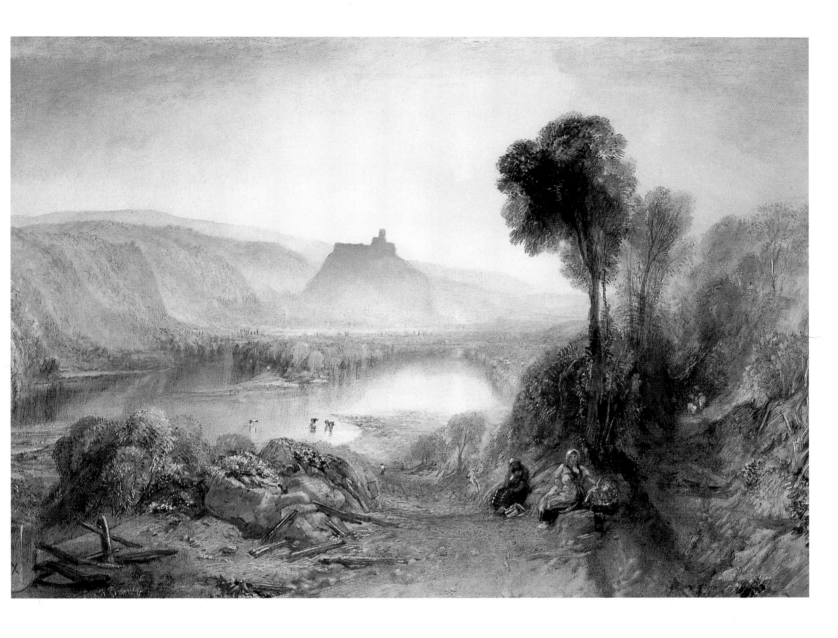

31. ***Prudhoe Castle,***

Northumberland,

ca. 1825.

Watercolour,

29.2 x 40.8 cm.

British Museum, London.

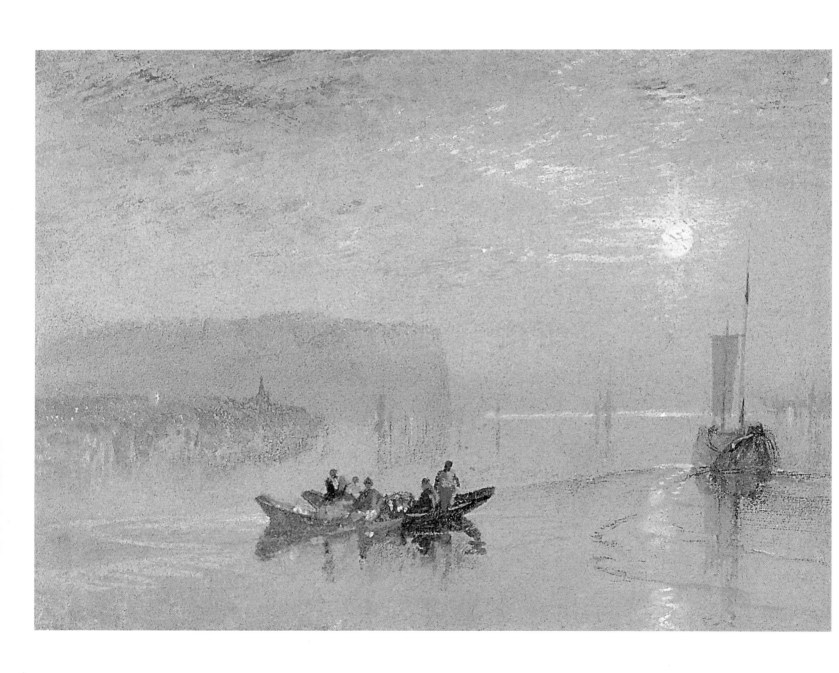

Then quickly he washed in the principal hues that he required, flowing tint into tint, until this stage of the work was complete. Leaving this drawing to dry, he took a second board and repeated the operation.

By the time the fourth drawing was laid in, the first would be ready for the finishing touches....

[Turner] stretched the paper on boards and after plunging them into water, he dropped the colours onto the paper while it was wet, making marblings and gradations throughout the work.

His completing process was marvellously rapid, for he indicated his masses and incidents, took out half-lights, scraped out highlights and dragged, hatched and stippled until the design was finished."

This swiftness, grounded on the scale practice in early life, enabled Turner to preserve the purity and luminosity of his work, and to paint at a prodigiously rapid rate.

Judging by the results of such speedy and creatively economical working processes, the intense pressures put upon Turner by the engravers seems to have stimulated rather than hindered his inventive powers.

During the 1830s Turner was busier than ever on his oils and finished watercolours. Large numbers of the watercolours are vignettes, or circular images with faded-out edges, for which Turner's incomparable control of tone, or the ranges of colour from light to dark, proved of enormous usefulness.

32. *Scene on the Loire (near the Coteaux de Mauves)*,
ca. 1828-1830.
Watercolour and gouache with pen on blue paper,
14 x 19 cm.
Ashmolean Museum, Oxford.

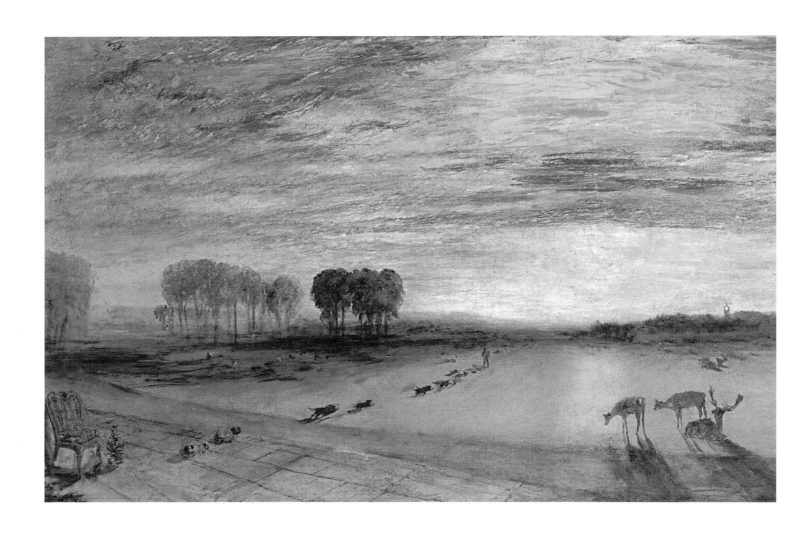

33. ***Petworth Park, with Lord***

 Egremont and his Dogs;

 Sample Study, ca. 1828.

 Oil on canvas,

 64.5 x 145.5 cm.

 Turner Bequest,

 Tate Britain, London.

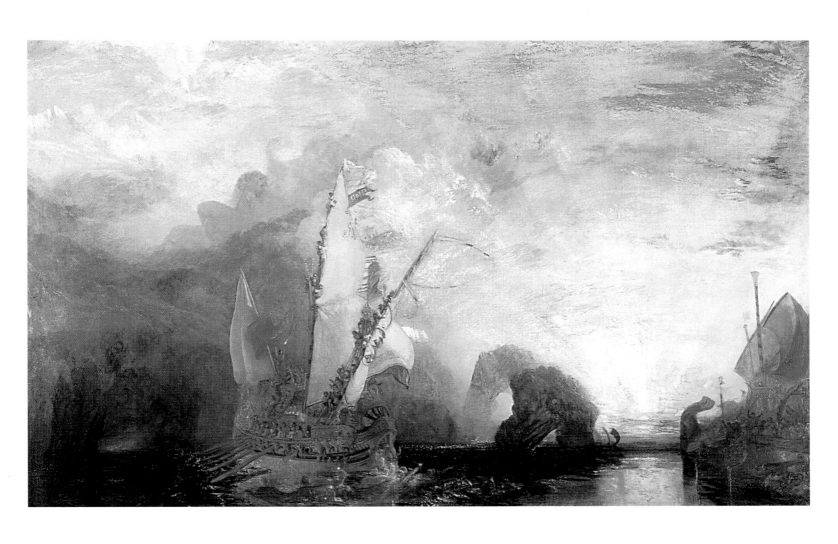

34. *Ulysses deriding*
Polyphemus - Homer's
Odyssey, R.A. 1829.
Oil on canvas,
132.5 x 203 cm.
Turner Bequest,
National Gallery, London.

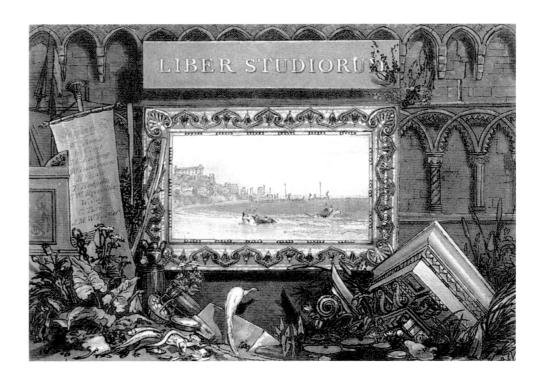

Topographical book illustration schemes also continued during the early-to-mid 1830s, with Turner creating designs for a survey of the Loire River, and for two explorations of the Seine River.

Naturally, Turner was always profoundly interested in colour theory; that involvement was greatly stimulated by his investigation of the science of optics undertaken in connection with the perspective lectures.

35. *Frontispiece of*
 "Liber Studiorum,"
 Mezzotint Engraving,
 1812.
 Tate Britain, London.

In 1818, he had introduced the subject of colour into those talks that were ostensibly about spatial and pictorial organization.

A subtle change took place in Turner's colour around that time.

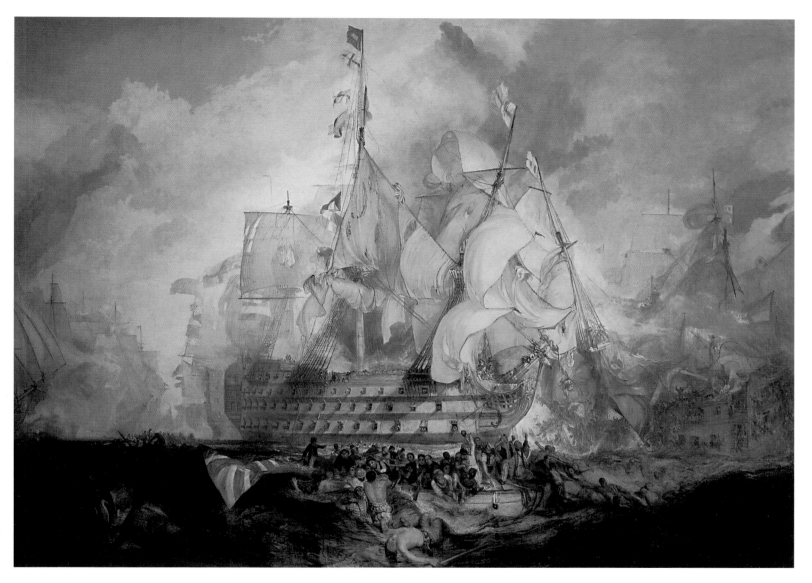

36. *The Battle of Trafalgar*,
1824.
Oil on canvas,
259 x 365.8 cm.
National Maritime
Museum, Greenwich, U.K.

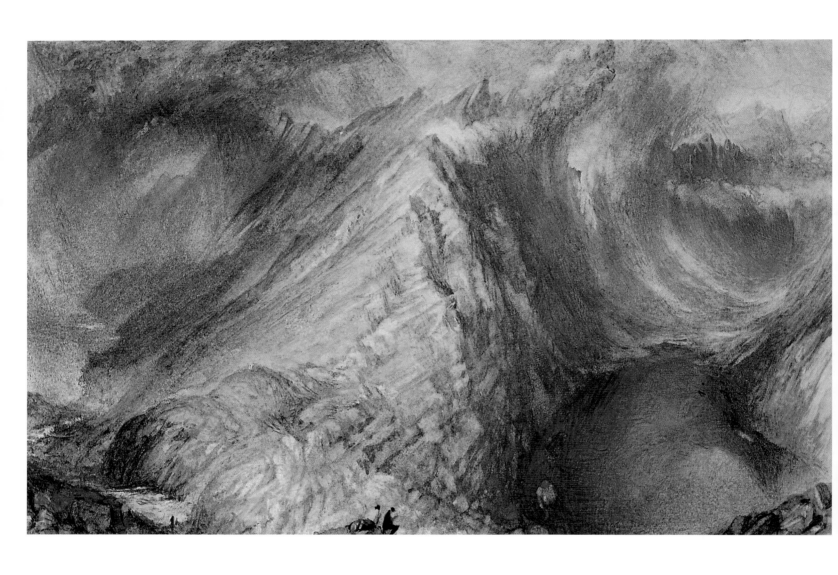

37. *Loch Coriskin*, ca. 1832.

Watercolour,

8.9 x 14.3 cm.

National Gallery of

Scotland, Edinburgh.

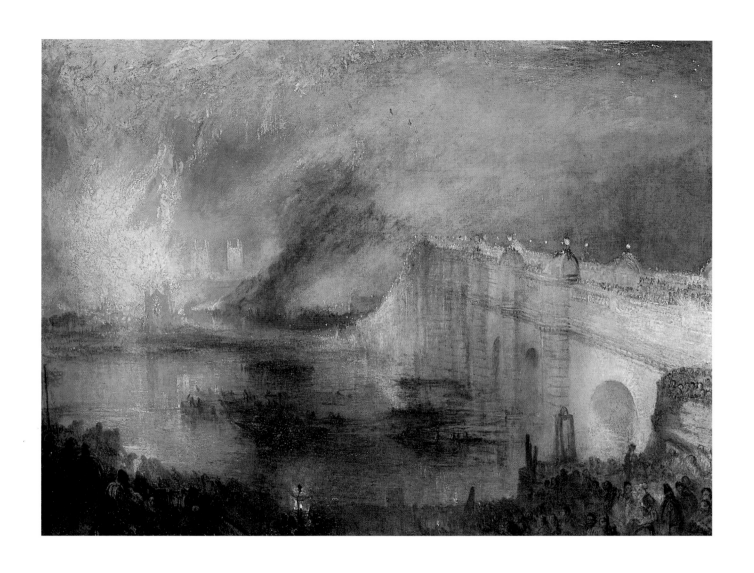

38. *The Burning of the Houses of Parliament B.I.*, 1835.
Oil on canvas,
92 x 123 cm.
The Philadelphia Museum
of Art, Philadelphia, Penn.

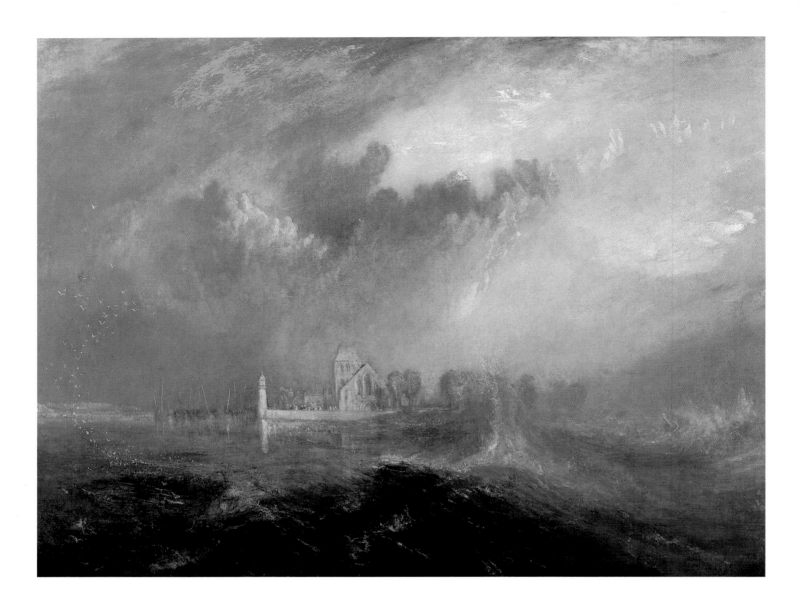

39. ***Mouth of the Seine,***
Quille-Boeuf, R.A. 1833.
Oil on canvas,
91.5 x 123.2 cm.
Fundaçao Calouste
Gulbenkian, Lisbon,
Portugal.

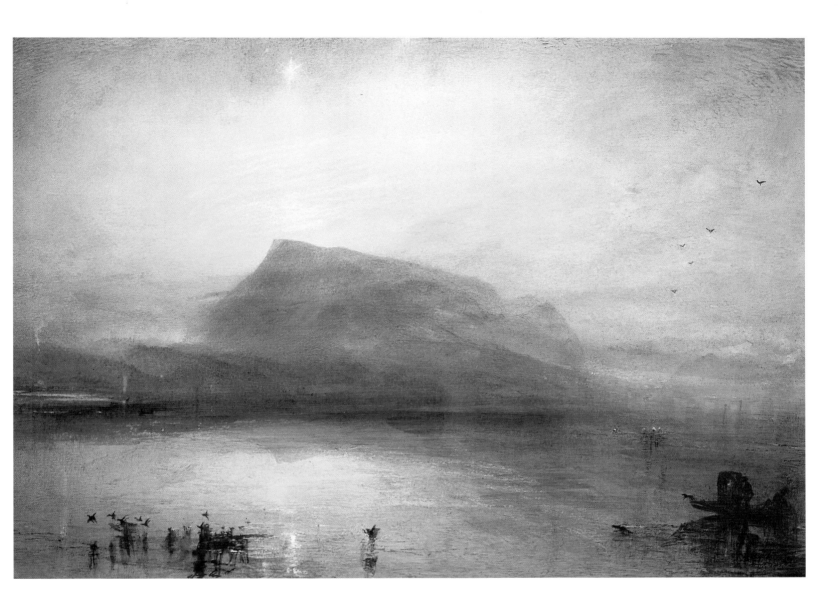

40. *The Blue Rigi:*

Lake Lucerne, sunrise,

1842.

Watercolour,

29.7 x 45 cm.

Private Collection.

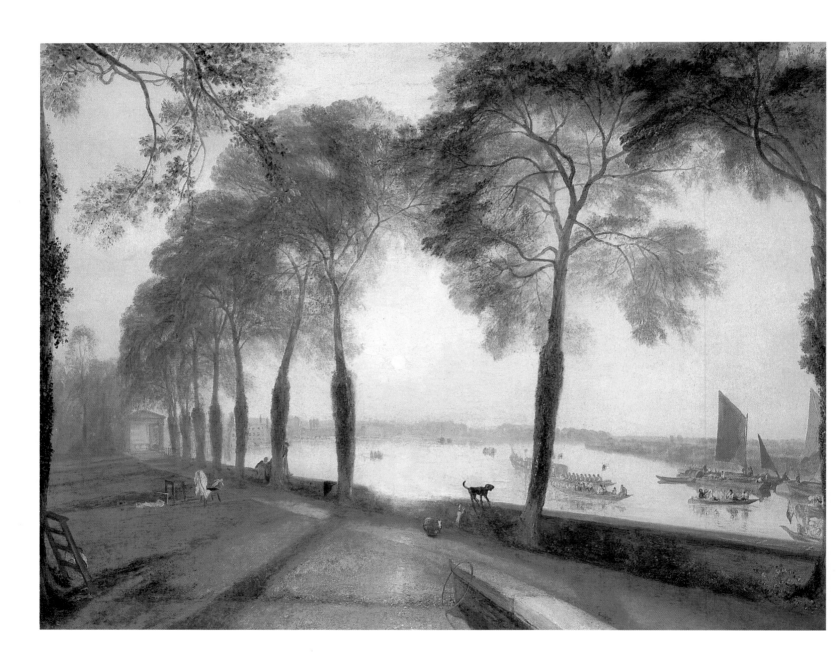

Thereafter a greater reliance upon the primaries and a more intense luminosity became apparent in his work. Turner's sense of the vivacity of colour was enormously stimulated by his visit to Italy in 1819, understandable, given that the colour sensibilities of most northern European artists are transformed by their contact with Italian light and colour.

Certainly a change in Turner's colour was recognized by 1823 when an encyclopedia published in Edinburgh stated that Turner's "genius seems to tremble on the verge of some new discovery in colour."

By the end of the 1820s, when paintings like *Ulysses deriding Polyphemus* (p. 45) appeared, such a "discovery" had been thoroughly consolidated and Turner began habitually creating ranges of colour that have yet to be matched by any other painter, let alone surpassed.

Turner demonstrated his virtuosity in public during the 1830s, sending to Royal Academy and British Institution exhibitions rough underpaintings which he elaborated to a state of completion during the days permitted for varnishing pictures.

Perhaps the most spectacular recorded instance of this practice occurred on the walls of the British Institution in 1835 when, in a single day, Turner painted almost the entirety of *The Burning of the Houses of Lords and Commons* (p. 49) now in Philadelphia.

41. *Mortlake Terrace, the Seat of William Moffatt, Esq. Summer's Evening*, R.A. 1827. Oil on canvas, 92 x 122 cm. National Gallery of Art, Washington, D.C.

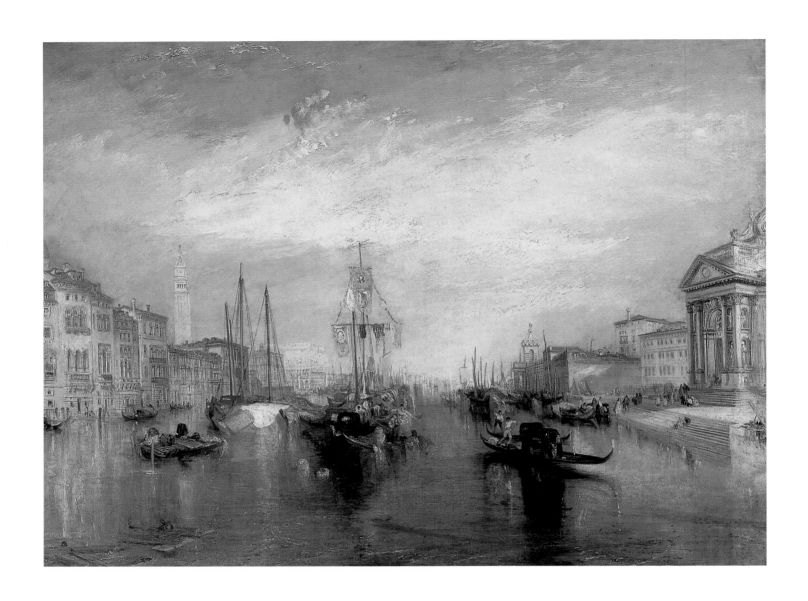

42. ***Venice, from the Porch of***

Madonna della Salute,

R.A. 1835.

Oil on canvas,

91.4 x 122 cm.

The Metropolitan Museum

of Art, New York.

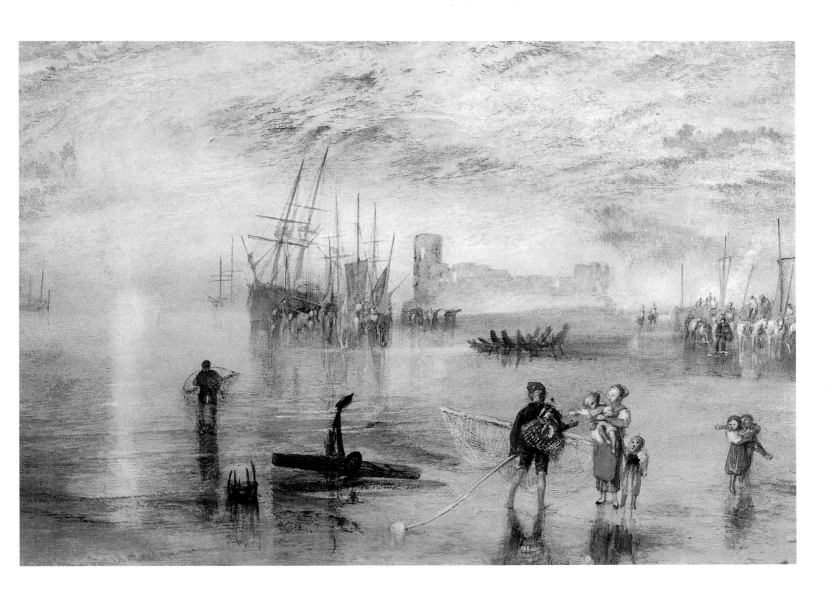

43. ***Flint Castle, North Wales***,

ca. 1835.

Watercolour,

26.5 x 39.1 cm.

Private Collection, U.K.

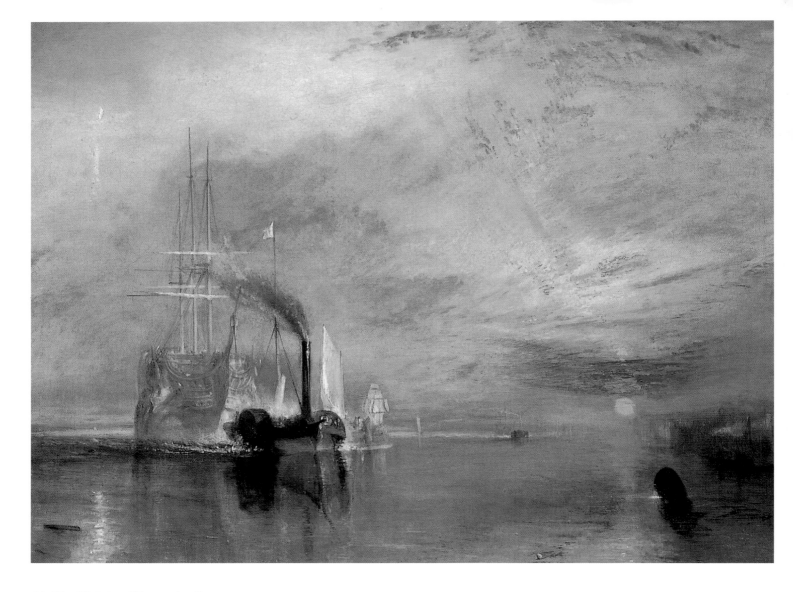

44. *The Fighting "Temeraire,"*
tugged to her Last Berth to
be broken up 1838,
R.A. 1839.
Oil on canvas,
91 x 122 cm.
Turner Bequest, National
Gallery, London.

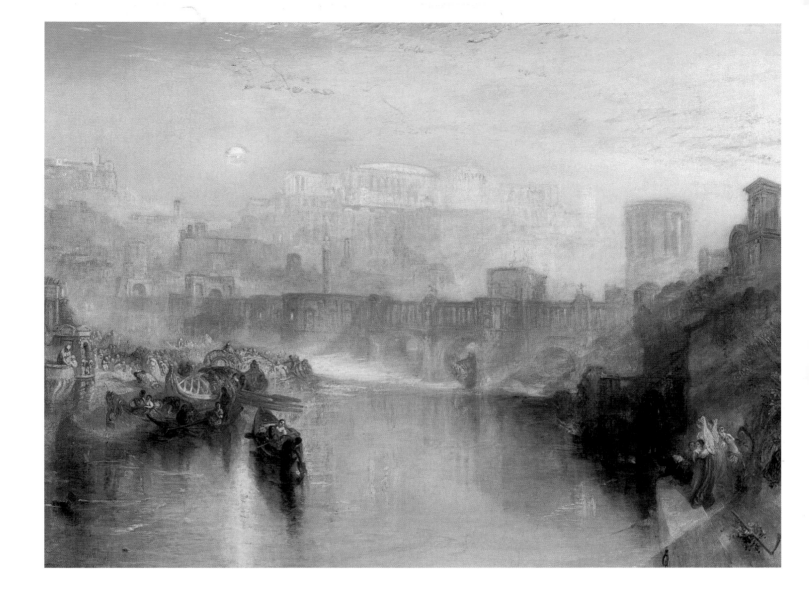

45. *Ancient Rome: Agrippina landing
with the Ashes of Germanicus.
The Triumphal Bridge and Palace of
the Caesars restored*, R.A. 1839.
Oil on canvas,
91.5 x 122 cm.
Turner Bequest, Tate Britain, London.

He had begun work at first light and painted all day, surrounded by a circle of admirers and without once stepping back to gauge the visual effect of his labours. Finally, the picture was completed.

As an eyewitness recorded:

"Turner gathered his tools together, put them into and shut up the box, and then, with his face still turned to the wall, and at the same distance from it, went sidelong off, without speaking a word to anybody, and when he came to the staircase, in the centre of the room, hurried down as fast as he could.

All looked with a half wondering smile, and Maclise, who stood near, remarked, 'There, that's masterly, he does not stop to look at his work; he knows it is done, and he is off.'"

46. *Slavers throwing overboard the Dead and Dying - Typhon coming on*,
R.A. 1840.
Oil on canvas,
91 x 138 cm.
Museum of Fine Arts,
Boston, Mass.

Turner continued to tour during the 1830s. An especially important trip took place in 1833. After exhibiting a view of Venice based on sketches made in 1819, Turner revisited the city, obviously to find out even more about it.

From 1833 onwards, the city would increasingly dominate Turner's Italian subject-matter, clearly because its frequently ethereal appearances struck a profoundly imaginative chord in him. He would return there in 1840.

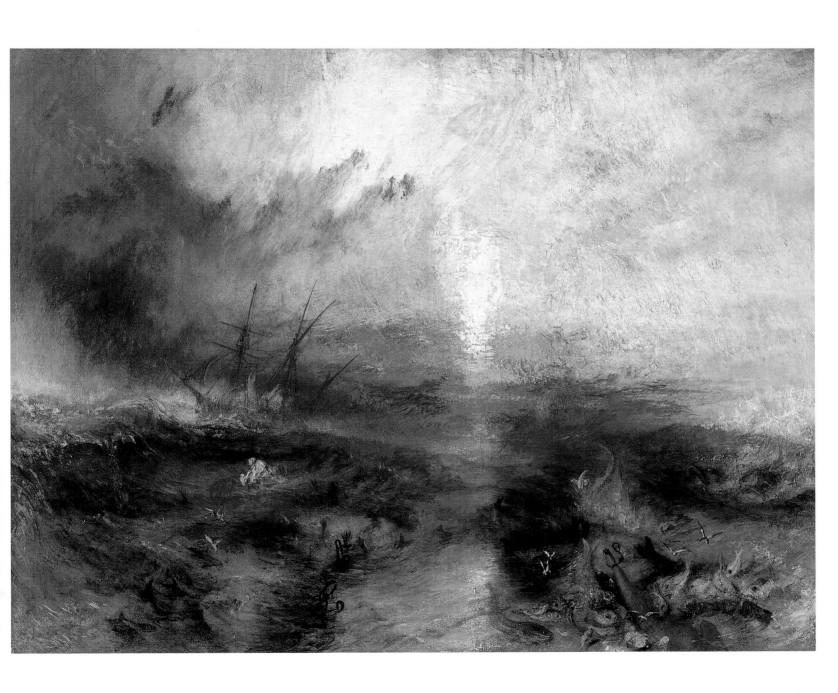

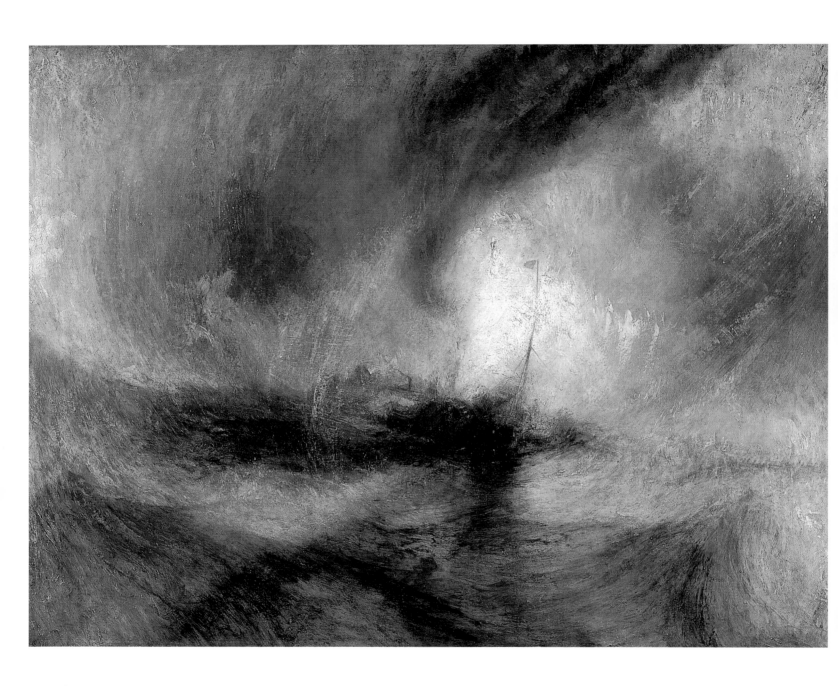

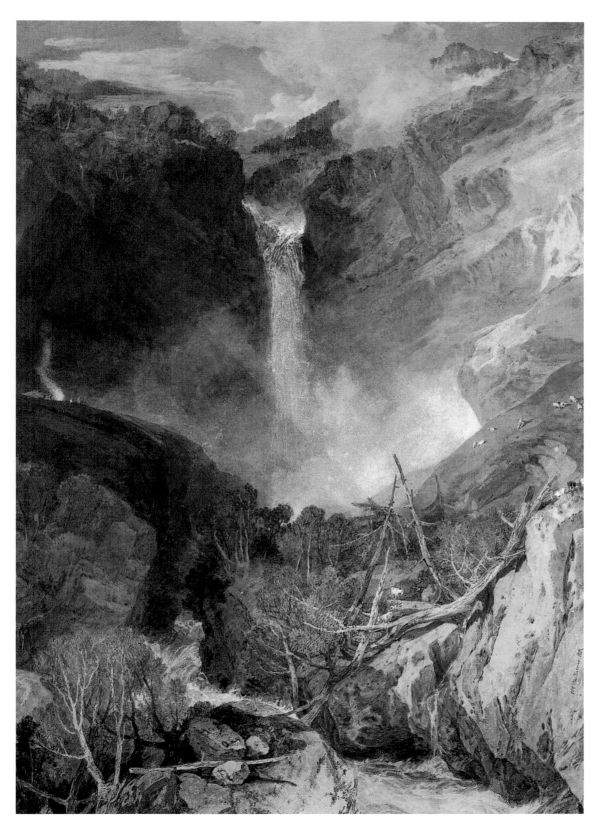

47. *Snow Storm -- Steam-*
Boat off a Harbour's
Mouth making Signals
in Shallow Water, and
going by the Lead.
The Author was in this
Storm on the Night the
Ariel Left Harwich,
R.A. 1842.
91.5 x 122 cm.
Turner Bequest,
Tate Britain, London.

48. *The Great Fall of the*
Reichenbach, in the
Valley of Hasle,
Switzerland, 1804.
Watercolour,
102.2 x 68.9 cm.
Cecil Higgins Art
Gallery, Bedford, U.K.

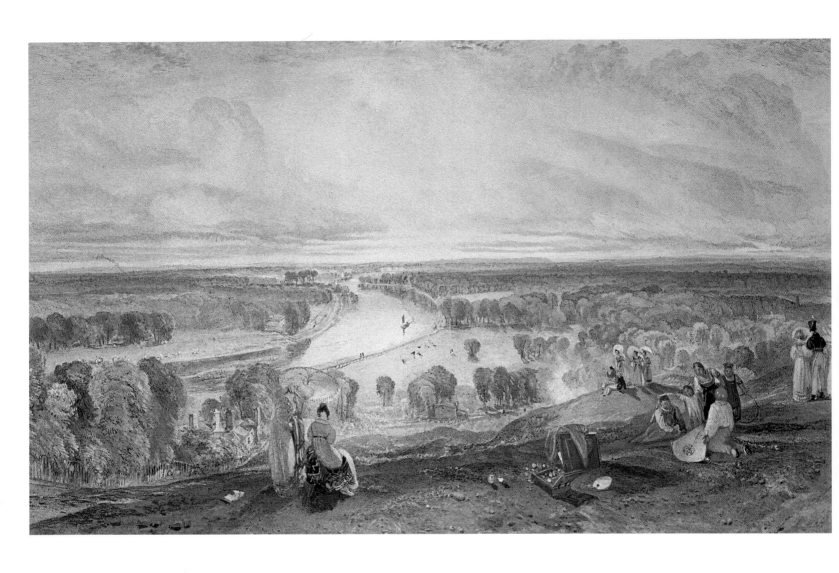

49. *Richmond Hill*, ca. 1825.

Watercolour,

29.7 x 48.9 cm.

Lady Lever Art Gallery,

Port Sunlight, Cheshire.

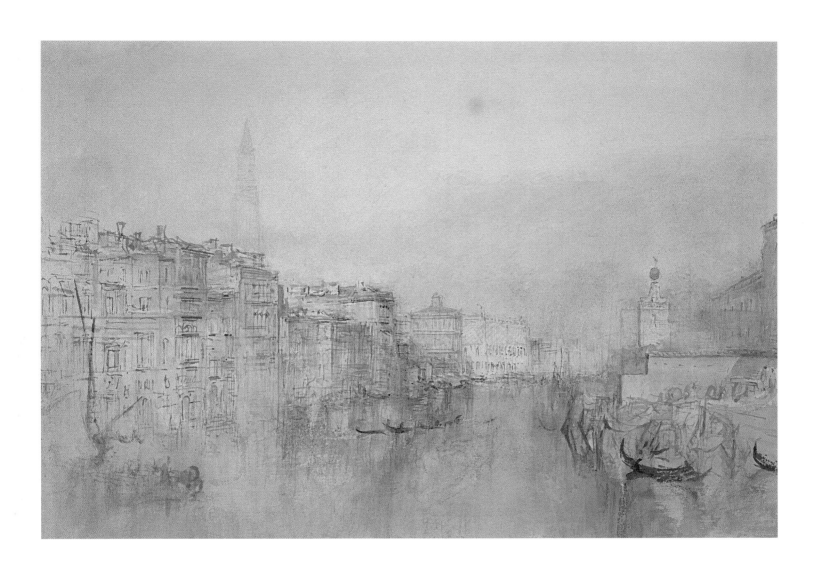

50. *Venice: the Grand Canal looking towards the Dogana*, ca. 1840. Watercolour, 22.1 x 32 cm. British Museum, London.

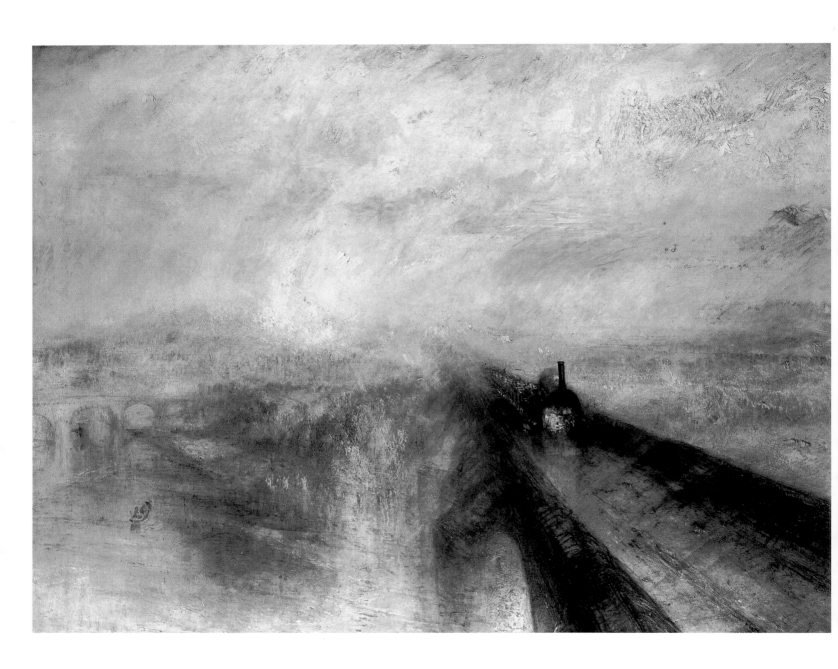

By 1838, the failure of the "England and Wales" series demonstrated that there was no further market for topographical engraving schemes (and thus no point in making watercolours for such projects).

Thereafter, Turner employed an agent to obtain orders for individual watercolours created in sets. For the imagery of these, the painter drew upon material gleaned from four tours of Switzerland undertaken annually after 1841.

The late Swiss watercolours arguably constitute Turner's loveliest landscapes in watercolour, if not the finest landscape watercolours ever created.

Throughout the 1830s and 1840s Turner kept up a steady flow of masterpieces in both oil and watercolour.

The public could not always make sense of the images or fathom their meanings, but that incomprehension did not lead the painter to make his depictions more visually approachable or simplify what he had to say -- if anything, the lack of understanding led him to make things even more difficult for his audience. Yet the public had little if any difficulty in understanding a masterpiece exhibited in 1839.

From the start *The Fighting "Temeraire"* (p. 56) was interpreted as an elegaic comment upon the passing of the age of Sail and the coming of the age of Steam, although the work equally celebrates the latter with its one small tug enjoying the ability to pull a large warship.

51. *Rain, Steam and Speed -- the Great Western Railway*, R.A. 1844. Oil on canvas, 91 x 122 cm. Turner Bequest, National Gallery, London.

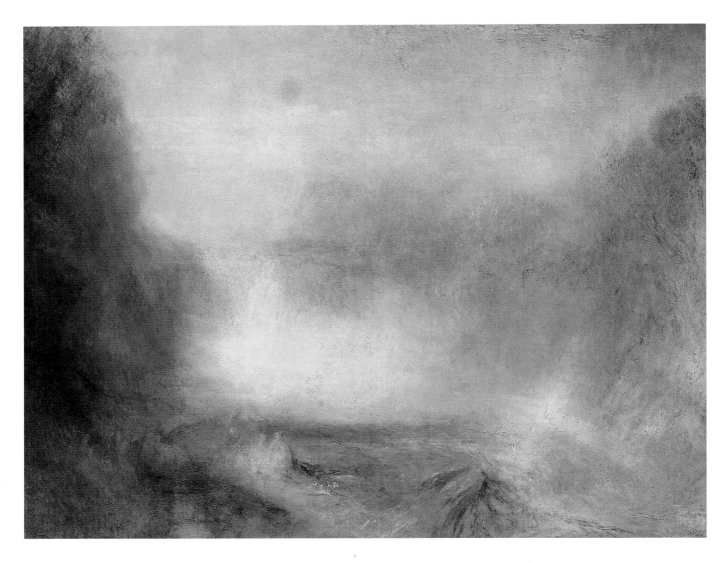

52. **The Falls of the Clyde**, ca. 1844-1846.
Oil on canvas,
89 x 119.5 cm.
Lady Lever Art
Gallery, Port Sunlight,
U.K.

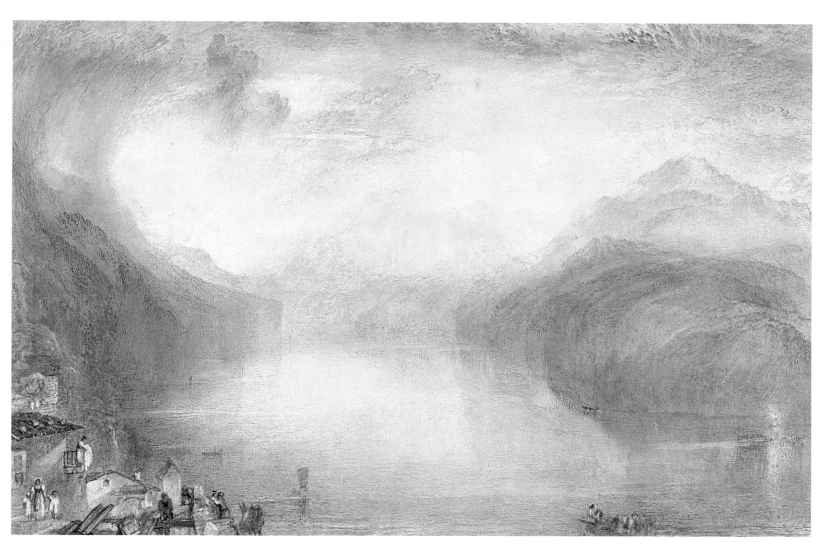

53. ***Lake Lucerne:***

the Bay of Uri from

above Brunnen, 1842.

Watercolour,

29.8 x 45.7 cm.

Private Collection,

U.S.A.

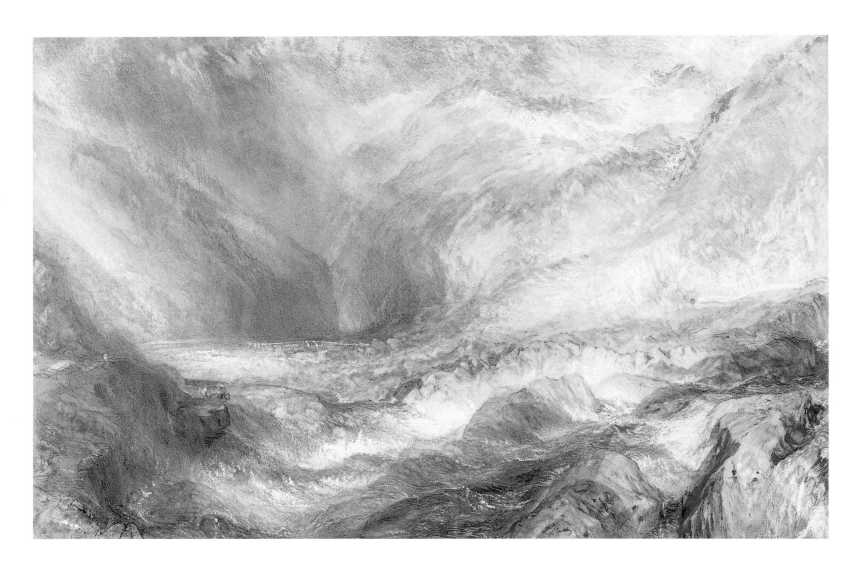

54. ***The Pass of Faido***,

1843**.**

Watercolour,

30.5 x 47 cm.

Pierpont Morgan

Library, New York.

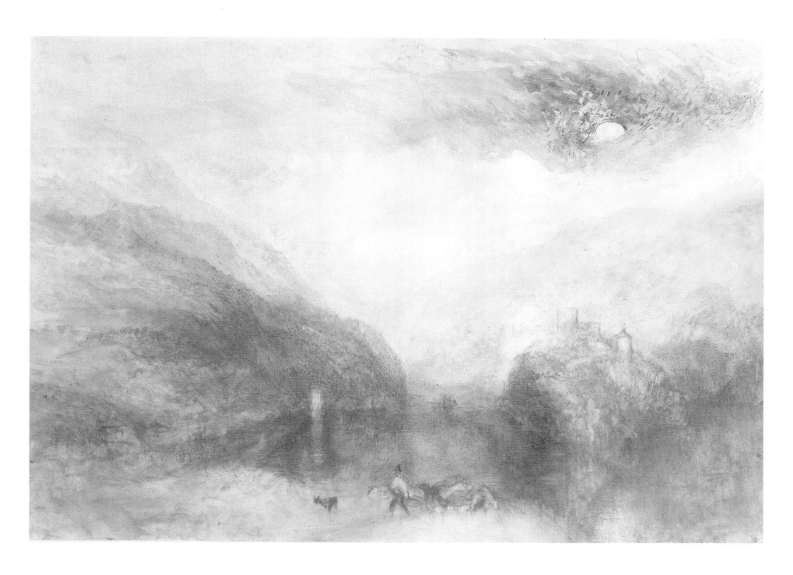

55. ***The Lauerzersee, with***

the Mythens,

ca. 1848.

Watercolour,

33.7 x 54.5 cm.

Victoria and Albert

Museum, London.

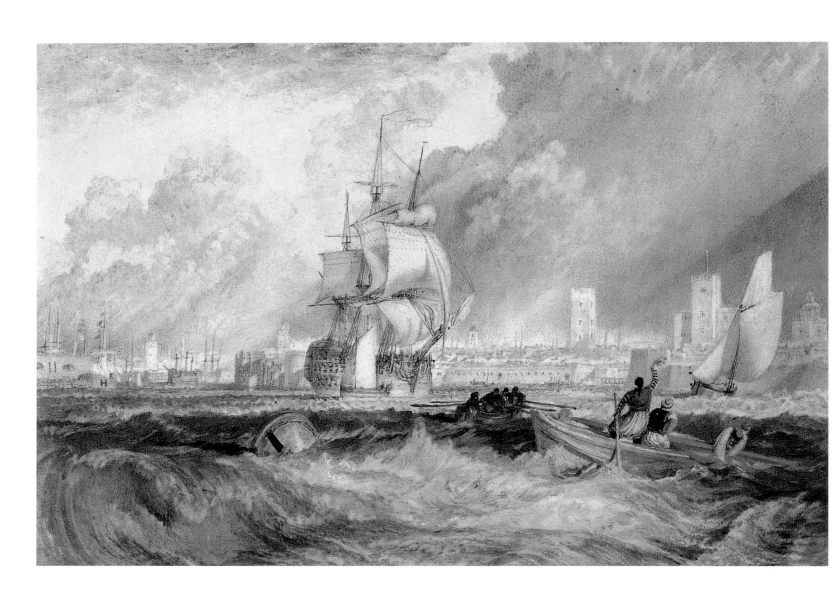

Five years later, Turner would make evident his excitement over the arrival of the modern industrial epoch in *Rain, Steam and Speed -- the Great Western Railway* of 1844 (p. 64).

During the 1840s, the painter became intrigued by polar exploration, yet another indication of his abiding interest in the opening-up of the world around him.

Around 1844, Turner printed new impressions from the *Liber Studiorum* plates and used those mezzotints as the basis for a set of "Late Liber" paintings that, although never displayed, might have been intended to summarise the artist's entire output. He also continued to produce oils for exhibition.

After about 1848 he apparently painted little, as the infirmities of old age struck hard. The four canvases that he exhibited at the Academy in 1850 could only have been produced by an extraordinary act of will.

Turner died on 19 December 1851 and was buried in St. Paul's Cathedral almost next to Sir Joshua Reynolds, as he had requested.

56. *Portsmouth*, ca. 1825.
Watercolour,
16 x 24 cm.
Turner Bequest,
Tate Britain, London.

He left a huge legacy of more than five hundred and fifty oil paintings, about two thousand finished watercolours and some nineteen thousand six hundred pencil and watercolour studies and sketches (in addition to over eight hundred prints).

His estate was assessed at £140,000, a sum whose exact modern value is incalculable, but which might conservatively be approximated if we multiply it a hundredfold.

His will contained two main provisions: that a gallery should be built to house the finished, unsold oil paintings and that a charity for impoverished artists should be created.

However, the will was contested by Turner's relatives and, unfortunately, overthrown on a legal technicality.

As a result, the relatives obtained the money and the charity was aborted. On the positive side, the British nation gained not only the finished oil paintings, but all the unfinished oils as well, plus all the watercolours, sketchbooks, sketches and studies that were still gathering dust in Turner's two studios. (However, not until 1987 would a gallery be created specifically to house them.)

His legacy lives on in a body of work that may have been equalled in size and quality, but which has never been surpassed for its beauty, power and insight into the nature of the human condition and the conditions in which we live.

57. *Scio (Fontana de Melek, Mehmet Pasha)*, ca. 1832. Vignette watercolour, 26 x 29 cm. Overall, Private Collection.

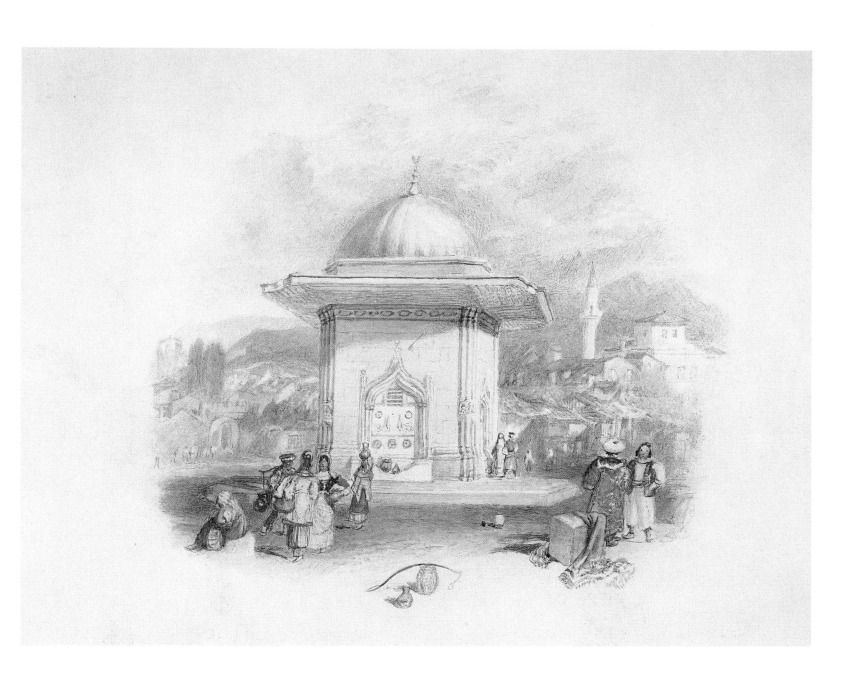

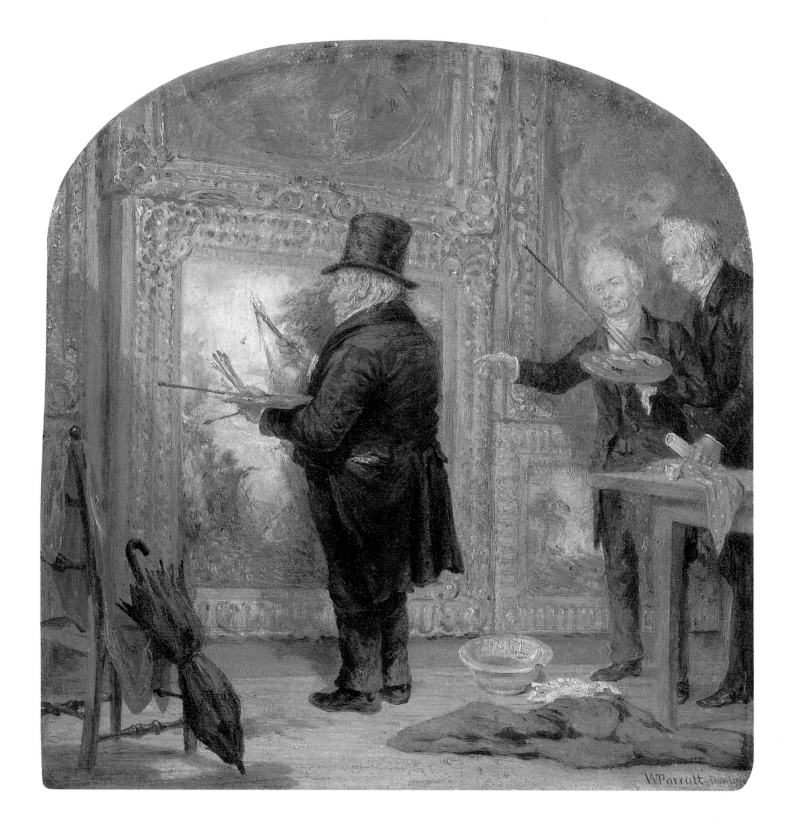

BIOGRAPHY

1775:
Birth of Joseph Mallord William Turner in London. His father was a barber and a wig maker.

1787:
Turner does his first drawings.

1789:
Enters the Royal Academy (stays until 1793) while working in watercolour with map-maker Thomas Malton. He creates his first collection of sketches and his first water-colour is shown in an exposition.

1793:
Turner embarks on one of his first voyages across England and Wales during which he does a number of sketches.

1794:
Turner starts to work as a topographic draftsman.

1796:
He paints his first oils.

1799:
He studies the ancient masters, particularly the paintings of Claude Lorrain.

1801-1802:
Voyage to Scotland and then to Switzerland before going to Paris to study the paintings in the Louvre.

1804:
Turner opens his own gallery.

58. William Parrot, *Turner on Varnishing Day*, ca. 1846.
Oil on wood panel, University of Reading, Reading, U.K.

1807:

The Royal Academy names him Professor of Perspective.

1808:

He illustrates the works of Cook, Byron and Scott. Turner spends the summer in Petworth where he will return frequently during his lifetime.

1817:

Leaves for a voyage on the Rhine and does his first Color Beginning.

1818:

Returns to Scotland in the fall.

1819:

Walter Fawkes presents more than sixty of Turner's watercolours in his London home. Turner takes his first trip to Italy, traveling to Turin, Naples, Cômes, Venice and Florence.

1821:

In order to illustrate "Rivers of France," he visits Paris, Rouen and Dieppe.

1825:

Takes a new voyage on the Rhine.

59. *Yacht approaching the Coast*,

ca. 1845-1850.

Oil on canvas,

102 x 142 cm.

Turner Bequest,

Tate Britain, London.

1827:

Turner resides for a time in the East Cowes Château, home of architect John Nash.

1828:

He returns to Italy and exhibits in Rome.

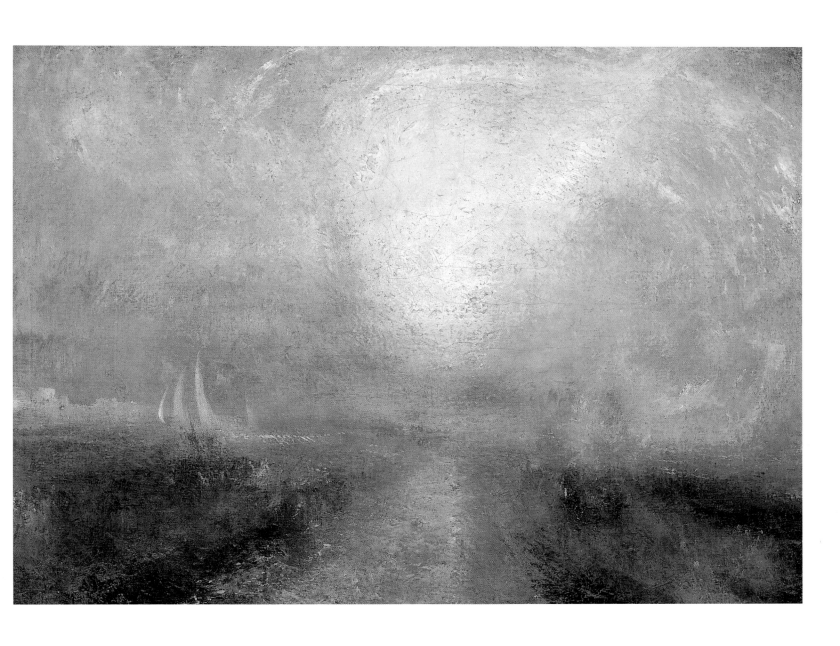

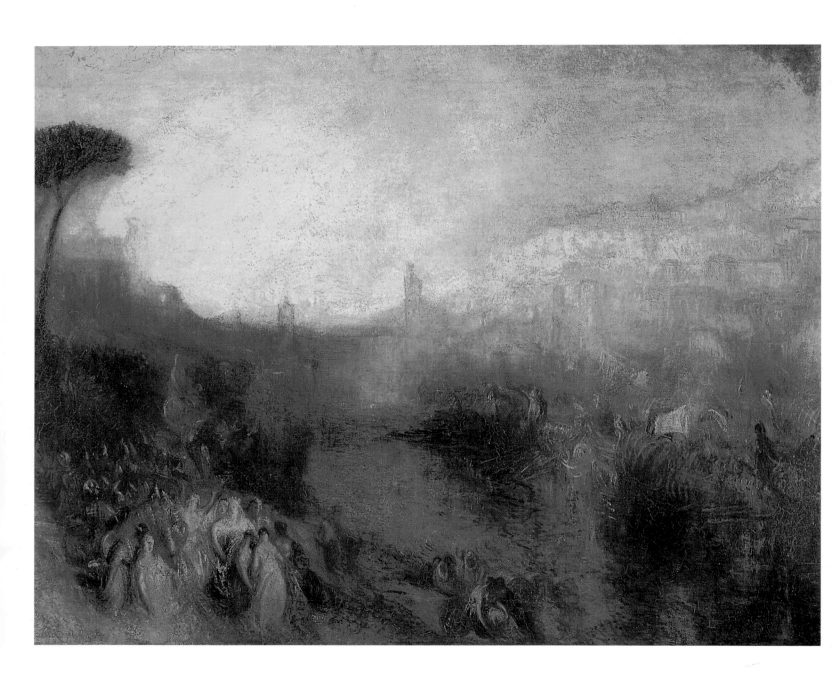

1829:

He presents thirty-five watercolours from the series England and Wales in London.
Turner then returns to Paris and visits Normandy and Brittany. His father dies the same
year.

1830:

He returns to Petworth where he practices fishing, hunting and music.

1832:

He probably meets Delacroix during a trip to Paris.

1835:

Turner takes a second trip to Venice and then passes through Austria and Germany.

1837:

His courses at the Royal Academy come to an end.

1840:

Meets with John Ruskin.

1841:

In the years that follow, Turner begins more frequently to return to Switzerland,
Northern Italy and Tyrol. He creates the late series of Swiss watercolours.

1845:

The short voyages that he takes to France in the spring and fall will be his last trips to
another country because of his deteriorating health. Because he is the oldest member of
the Academy, he becomes the Treasurer.

60. *The Departure of the
Fleet*, R.A. 1850.
Oil on canvas,
91.5 x 122 cm.
Turner Bequest,
Tate Britain, London.

1850:

Last exposition at the Royal Academy.

1851:

Turner dies on 19 December in his Chelsea home. A solemn funeral is given at St. Paul's
cathedral, as Turner had requested before his death.

LIST OF ILLUSTRATIONS